IMAGES
of America

GREAT FALLS
OF PATERSON

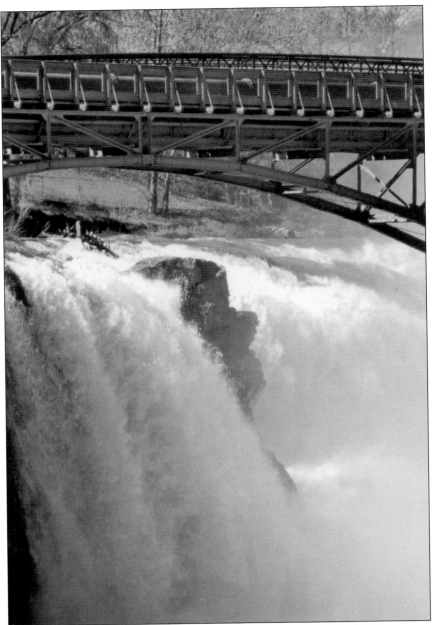

When the Passaic River is at full flood mode, the mass of water is in violent motion and roaring as it strikes the rocks below, rushing through the gorge creating clouds of spray that fill the atmosphere. (Author's collection.)

ON THE COVER: This is an old photograph of the Great Falls, made from a glass negative from the early 1900s. The Falls are 77 feet high and 280 feet across. At their base is a wooden swimming pool also used as a swimming school. Since this time, the Falls have become a national historic landmark and a state park and, in March 2009, were authorized for designation as a national historical park. (Richard Gigli collection.)

IMAGES
of America

GREAT FALLS
OF PATERSON

Marcia A. Dente

ARCADIA
PUBLISHING

Published by Arcadia Publishing
Charleston SC, Chicago IL, Portsmouth NH, San Francisco CA

Printed in the United States of America

Library of Congress Control Number: 2009943921

For all general information contact Arcadia Publishing at:
Telephone 843-853-2070
Fax 843-853-0044
E-mail sales@arcadiapublishing.com
For customer service and orders:
Toll-Free 1-888-313-2665

Visit us on the Internet at www.arcadiapublishing.com

*Dedicated to the memory of Mary Ellen Kramer and Harry Dente,
inspirations for this book. I am grateful for all they were and still are.*

CONTENTS

ACKNOWLEDGMENTS

Deep appreciation to everyone who contributed to the making of this book. The Great Falls Cultural Center was invaluable, particularly Glenn Hutton, community relations aide, who provided a wealth of information, and Joanne Cecchetti, coordinator. Vincent Waraske, the Paterson historian who sadly passed away on May 28, 2010, read the manuscript twice for authenticity. Thank you to Lawrence F. Kramer, former mayor of Paterson, my dear friend, and the first person I contacted when the book proposal was approved, for all his enthusiasm and support; to Jack DeStefano, director of the Paterson Museum; Bruce Balistrieri; and Joe Costa, photo archivist and one-time neighbor of my parents on Front Street, for providing images that appear in this book; to Paula Inturissi, my old friend from my Paterson Library days, who introduced me to Bruce Bardarick, local history librarian, for all the research materials used; and to Richard Gigli, former photographer for *The Record*, for his images. A huge thank you to the Library of Congress for allowing me usage of the photographs of the S.U.M. and raceway; to the Rochester Public Library, for its digital images; to Alison Faubert, of the Passaic County Historical Society; to Jason Hansen, for his knowledge of Adobe Photoshop; and to Christine Fontanazza, superhero and last-minute savior.

Thank you to Jennifer Papale Rignani for giving me the courage and support to write this book and providing me with the contact person at Arcadia Publishing; to Henry Papale, whose help has been never-ending, I could have never finished this project without him; and to Roberta Papale, who read, read, read, and reread the drafts of this text, editing and making grammatical corrections. They are the two reasons why you are reading this book.

And lastly, thanks to my parents, Harry and Jill Dente, for living on Front Street, so close to the Falls and the surrounding area. I grew up around the Falls my entire life and watched the area develop, over the years, into what it has become today—a national natural landmark, a state park, and now a national historical park.

INTRODUCTION

The heart of Paterson's legacy is appropriately called the "Cradle of American Industry," and it all started with the Falls. At the end of the last glacial period some 12,500 years ago, the Passaic River cut a deep swath through the basalt, which contained it, eventually plunging over the 77-foot precipice forming the Great Falls. These Falls would play a central part in the early industrial development of both New Jersey and the nation.

Paterson began as a planned industrial center, one of the first in the country. The site was earmarked over a century earlier by the Society for Establishing Useful Manufactures (S.U.M.), which included Alexander Hamilton. The group was impressed by the spectacular Passaic River Falls as a potential source of manufacturing power. Hamilton's foresight about the industrial potential of the Great Falls was the key factor that impelled the S.U.M. to create the town named after the governor of New Jersey, William Paterson. He signed the charter for the corporation in 1792 for the town that still bears his name. Under Hamilton's entrepreneurial guidance, the city of Paterson was specifically designed to foster business, and the Falls became a natural energy source. Maj. Pierre L'Enfant designed an innovative hydraulic system, known as the raceway, which would use three-tiered canals to channel millions of gallons of water to power mills and factories. In 1794, the initial raceway was completed and water was brought to the first mill, which produced calico goods. This laid the foundation for a substantial textile industry that has flourished into the present.

A city grew out of the S.U.M.'s 700 acres above and below the Great Falls on the Passaic River, and its first citizens were primarily workers at local factories. Even though the S.U.M. did not carry its original objectives to fruition, it did manage to develop real estate around the Great Falls and supply the energy needed to power the multitudinous industries, which eventually included textiles, locomotive manufacturing, guns, aircraft engines, and submarines. Despite increased industrial activity in the vicinity, the popularity of the Falls was barely diminished throughout the early and mid-1800s. Facilities there went through processes of enlargement and improvement. In 1850, Cottage on the Cliff at Passaic Falls had target practice ranges for military companies, and attached to the cottage was a spacious dining hall, which could accommodate 200 people for dinner. In 1844, the original Clinton Bridge over the chasm of the Falls was replaced with a covered structure. John Ryle built a third bridge, open at the top with paneled sides and made of wood. This bridge was declared unsafe in March 1868 and replaced by an iron structure, open at the sides to allow a view of the Falls. Constructed by the Watson Machine Company, this 85-foot bridge remained in place until 1888, when it was replaced by another iron bridge 125 feet in length. On the day the United States declared war on Germany, April 6, 1917, this fifth bridge was locked and closed to the public to prevent sabotage of the hydroelectric plant. Later the flooring and side rails were removed, and for more than 50 years, crossing a bridge over the chasm by pedestrians ceased. Over a span of time, the Falls and surrounding acreage developed into a national historic landmark and a state park. On March 30, 2009, Pres. Barack Obama signed a bill authorizing the Falls and the surrounding area to become a national historical park.

Persons walking across the Wayne Avenue Bridge can watch, paint, or photograph as the water cascades over the rocks—at times thundering over when there has been a heavy rainfall or melting snow and ice from the Passaic River or merely trickling when there has been no rain at all for a long period of time.

There have been many books written about Paterson but not about the Great Falls alone. Without the Falls, there would not be a Paterson, and this is my attempt to show their historic importance in order to acknowledge the role they played in making Paterson and the United States an industrial giant. They may not be as impressive as they were more than 200 years ago, but the Great Falls and their environs retain a natural beauty today. Visitors are lured by the Falls and will be lured to Paterson's Great Falls National Historical Park and perhaps see the majesty of the water and its beauty just as Alexander Hamilton did one day in 1791.

One

THE BEGINNING

Approximately 13,000 years ago, at the end of the last glacial period, the Falls were formed as the Passaic River had formerly followed a shorter course through the Watchung Mountains near what is now called Summit. The previous course the river took was blocked by a newly formed moraine (formed during a temporary halt in the final retreat of the glacier). Glacial Lake Passaic ponded behind the Watchungs and as the ice receded, the river managed to escape and found a new circuitous route around the end of the mountains. It was there that the spectacular 77-foot Great Falls were carved out through the underlying basalt that had been formed approximately 200 million years ago. It took about 3,000 years for the area to be settled by a nomadic group of hunter-gatherers.

The Lenni-Lenape Indians were the original inhabitants of the landlocked wilderness of the Paterson area. They knew the Falls as a prime camping and fishing site they called Totowa (to sink or be forced down beneath the waters' weight), a tribute to this awesome mass of water. In the 1620s, Dutch missionaries and trappers began to settle near the Great Falls, intrigued by a description given by friendly Native Americans. Property disputes between the Dutch and the Lenape followed. Hunting, trapping, and trading of animal pelts began to deplete formerly rich regional supplies. Exposure to previously unknown European illnesses took a toll on the Lenape, curtailing the tribe's ability to stem further encroachment by the new settlers. In 1679, the Dutch obtained the first tract of land and began farming at what is now the site of Paterson. In 1791, there were only 10 farmhouses here and an inn, the Godwin Tavern (also known as the Washington House), a place of entertainment for visitors to the Falls.

During a lull in the fighting of the American Revolution, visitors such as George Washington, Alexander Hamilton, James McHenry, and the Marquis de Lafayette stopped for a picnic lunch at the majestic 77-foot-high Falls. This was Hamilton's first view of the Falls, and it is with Hamilton that the town's history begins.

Basalt rock surrounds the Falls and the area above the cascade, called the Valley of the Rocks. William Carlos Williams describes in book one of his poem *Paterson*, "Paterson lies in the valley under the Passaic Falls its spent waters forming the outline of his back. The river comes pouring in above the city and crashes from the edge of the gorge in a recoil of spray and rainbow mists." (Paterson Museum, photograph by Michael Spozarsky.)

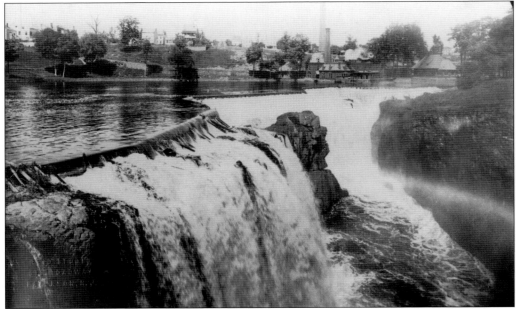

The first record known of white men visiting the Falls is an account of two Labadist missionaries in March 1680, who, with an Native American guide, came up the Passaic River to the present site of Passaic and continued on foot to the Falls. It is possible that others had seen the Falls before this, for the Acquackanonk tract was secured in April 1678. (Paterson Museum.)

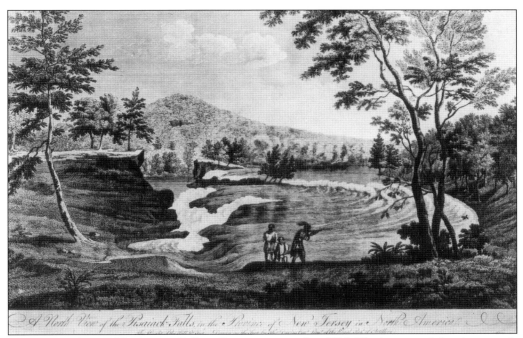

This is an etching of the Passaic Falls in Paterson created in 1900. The bottom of the photograph reads: "A north view of the Pisaiack Falls in the province of New Jersey in North America. Drawn on the spot by Tho. Davies Capt. Of the Royal Reg. of Artillery." The basin was the hunting grounds for local Native Americans who came here to fish, for at times the basin was thick with fish of all kinds. (Paterson Museum.)

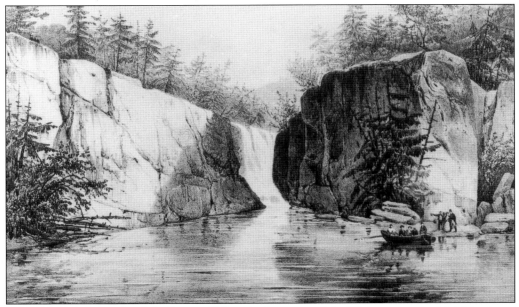

Pictured is a lithograph of the Passaic Falls, which is part of the Welcome to the Neighborhood Collection: The Paterson Immigration Experience from 1860–1960. The wonders of the Falls were advertised in New York newspapers as early as 1770. (Paterson Museum.)

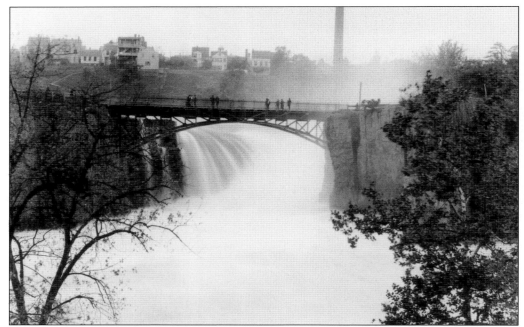

Onlookers venture to the Falls for an outing in the 1800s to watch as the water cascades over the rocks near the mills. Since the first European gazed on this natural wonder in the 17th century, countless visitors have written about it after having visited the area. (Paterson Museum.)

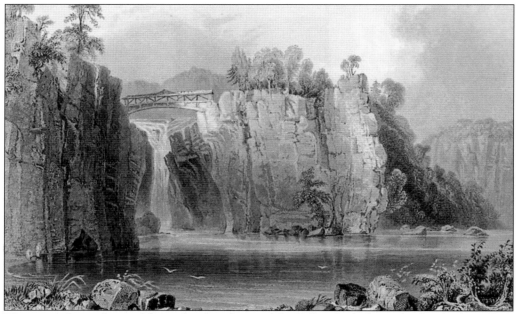

This is another etching of the undeveloped area of the Falls, which shows the first bridge to link both sides of the chasm then known as the Totowa Falls. There have been eight bridges built, the first in 1827 by Timothy Crane after buying the property around the Falls. It was known as the Clinton Bridge, pictured above. The bridge was not complete and open to the public until months later. (Paterson Museum.)

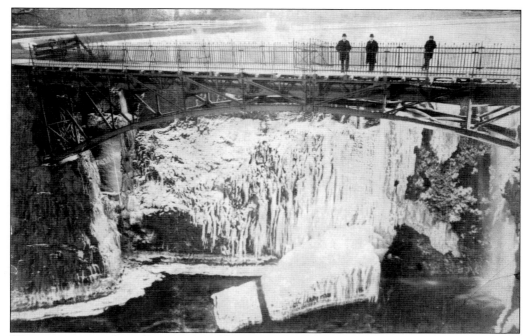

Winter visitors to the Falls were now able to view the frozen waters from a new bridge. By this time, Crane had sold the Falls grounds to Peter Archdeacon, who greatly improved the property and placed the second bridge over the chasm in 1844. (Paterson Museum.)

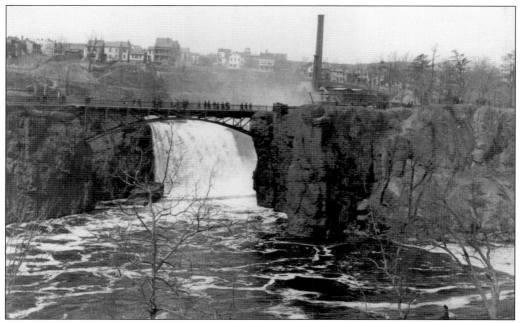

Paterson had been built up and homes sit on the land above the Falls, an area that originally had 10 farming families. The river is flowing toward the Falls, and workers use this as a passageway back and forth to the mills. (Paterson Museum.)

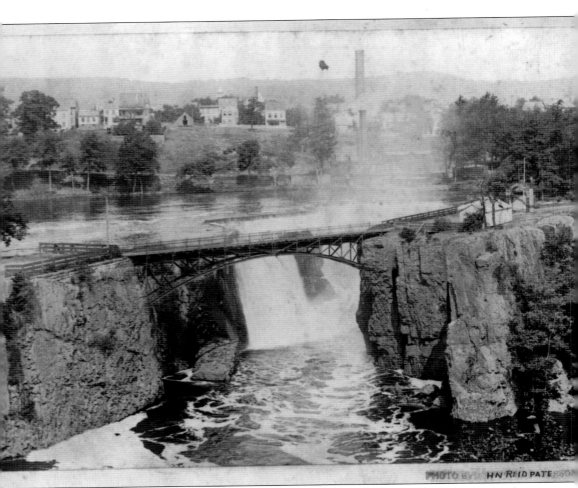

The property next came into the hands of John Ryle, who built the third bridge sometime between 1844 and 1868. It was a paneled bridge, open at the top. The first two bridges were covered, and all three had been made of wood. (Paterson Museum.)

Winter at the Passaic Falls around 1900 makes the Falls seem to be frozen in time. It was a fine place, summer or winter, to visit. (Paterson Museum.)

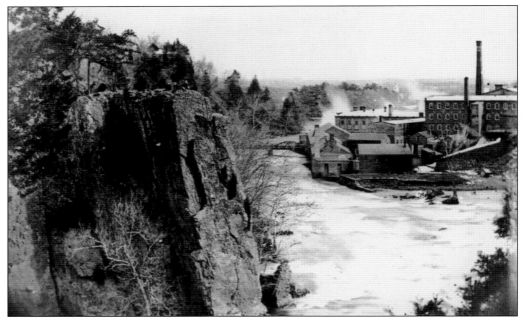

Shown here are the river rapids below the Falls and the John Ryle Bridge. This bridge remained until it was declared unsafe by Ryle himself in March 1868. Ryle stated that the bridge would be replaced with an iron structure that would be open on the sides, so as not to hide a view of the Falls. (Paterson Museum.)

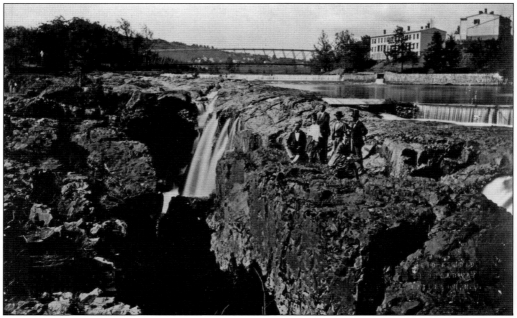

The first iron bridge and fourth overall to cross the chasm was placed there July 2, 1868. It was 85 feet long and built by the Watson Machine Company, builders of the Post Patent bridges. This bridge remained until a 125-foot-long fifth span was set in place in 1888 and opened to the public that December. (Paterson Museum.)

For many years, it was the amusement center of the area. Fireworks were first displayed here in 1829 by Timothy Crane, and for many years Fourth of July pyrotechnic displays were celebrated from the Falls. Many thousands came from afar to witness tightrope walkers who would cross from the bridge to Morris Mountain over the basin with more than 100 feet of air below them. This is a *c.* 1900 tightrope walker at the Falls. (Paterson Museum.)

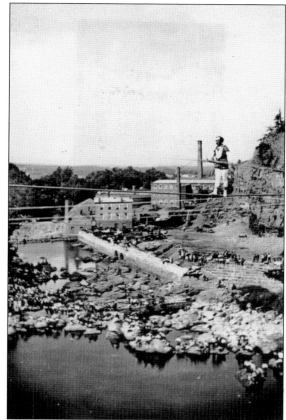

Photographs from black-and-white glass negatives provide the early views of the Passaic Falls prior to a bridge being built. Visitors had easy access to the picturesque view and could feel the spray of the water close up. (Library of Congress Prints and Photographs Division.)

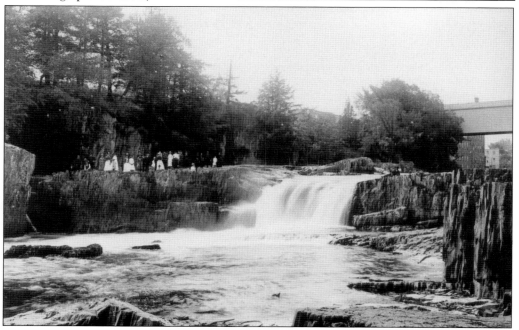

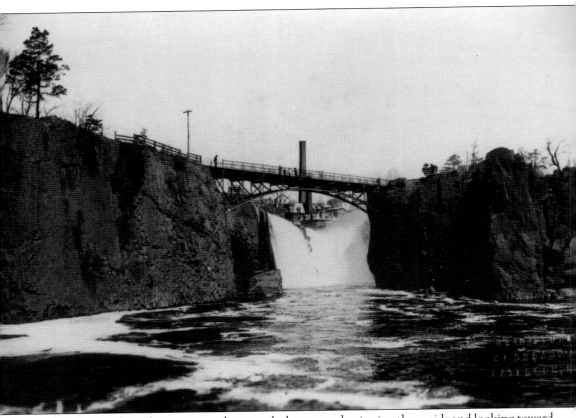

A black-and-white glass negative photograph shows people viewing the rapids and looking toward the basin of the Falls with the new iron bridge that is open on both sides, providing a better view of the Passaic Falls. (Library of Congress Prints and Photographs Division.)

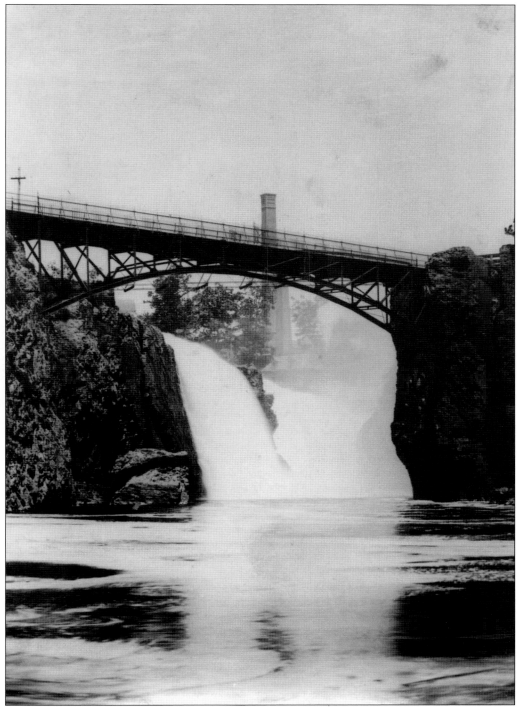

In order to prevent sabotage of the hydroelectric plant at the Falls, this bridge was closed to the public the day the United States declared war on Germany in 1917. For more than 50 years, pedestrians were prohibited from crossing a bridge over the chasm. (Passaic County Historical Society.)

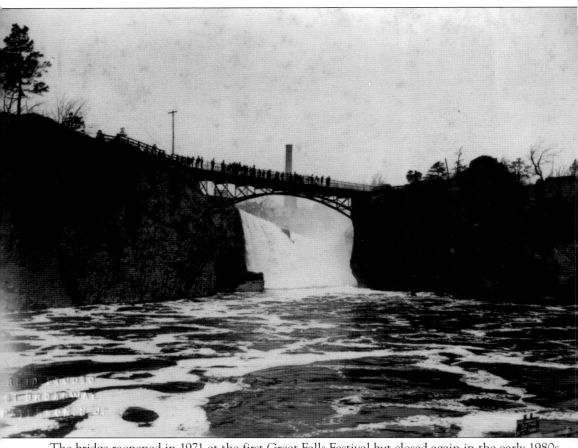

The bridge reopened in 1971 at the first Great Falls Festival but closed again in the early 1980s when it was found to be unsafe. (Passaic County Historical Society.)

Two

ALEXANDER HAMILTON'S VISION

Following the Battle of Monmouth on June 28, 1778, George Washington, his aide James McHenry, the Marquis de Lafayette, and Alexander Hamilton, while on their way to the war camp in Paramus, stopped for a picnic lunch on July 10 at what was known then as the Totowa Falls. During the stop, McHenry spent a significant amount of time exploring the rock formations around the Falls and described cracks, creases, and crevasses in the basin and river below the Falls as a "place well formed for love." In 1780, some of Washington's troops were assigned to guard the land from the vantage point offered by the cliffs above the Valley of the Rocks near the Great Falls.

Hamilton submitted a "Report on Manufactures" to Congress on December 5, 1791. In it, he outlined the necessity for the country to move along an industrial course and the importance of a domestic manufacturing capability that would provide articles of prime necessity, particularly cotton goods. It was the catalyst for the creation of the Society for Establishing Useful Manufactures. Hamilton's report is still regarded as one of the best treatises on the subject of manufactures ever written. The report emphasizes the practicability of extensively producing cotton cloth in the United States. And he had one place in mind for a "New National Manufactory."

As first secretary of the treasury, Hamilton was searching for an industrial capital. He remembered the town where he stopped for lunch and selected the land surrounding the Great Falls and the power of the Passaic River for a proposed manufacturing settlement. The enormous height of the Falls, their 77-foot drop into a deep chasm below, and the surrounding terrain had characteristics that were essential for the utilization of waterpower at that time. Hamilton's plan for economic independence for the new American republic at the end of the 18th century called for tapping the inestimable power of the Great Falls. It had what he needed, and he visualized a potential source of abundant waterpower behind the great cataract.

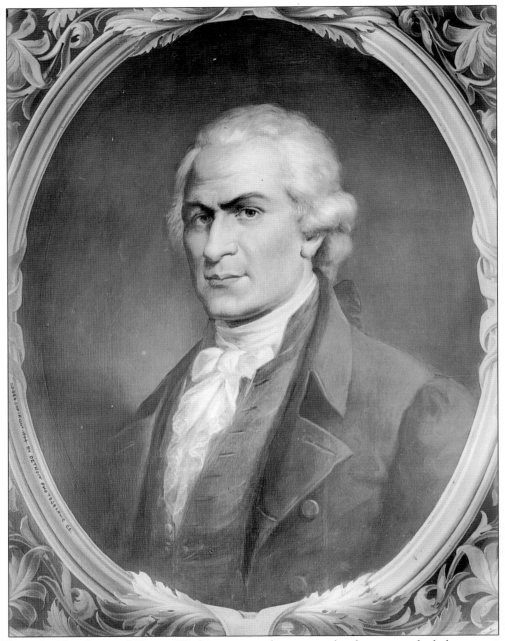

Alexander Hamilton and George Washington stood next to each other on a rocky ledge opposite the Falls, struck by their dramatic beauty, where Hamilton envisioned them powering a great manufacturing center that would supply the needs of the country. Here there was enough waterpower to turn mill wheels, and the river could carry manufactured goods to marketing centers. In 1791, Hamilton filed his "Report on Manufactures" with Congress. In the power of the Great Falls, Hamilton saw America's first industrial city. He chose July 4, 1792, to establish the Society for Establishing Useful Manufactures; from that day on, Alexander Hamilton and Paterson were forever linked. (Library of Congress Prints and Photographs Division.)

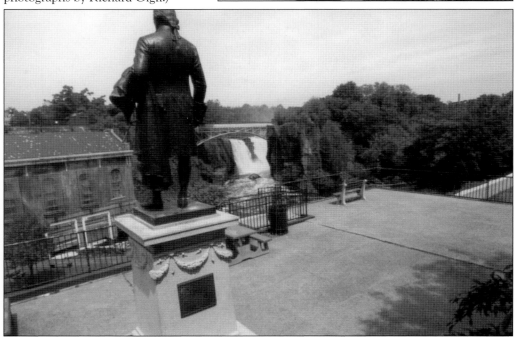

This statue of Alexander Hamilton looks out over the Great Falls, the inspiration for Hamilton's decision to build America's first industrial city at this site. In 1905, Franklin Simmons created this sculpture, which was placed in front of city hall. In 1947, it was moved to Post Office Plaza, where visitors to Paterson would be able to see it on their arrival, and on April 13, 1964, it was moved to its present site, where Hamilton can gaze upon the Falls that inspired him. (Both, photographs by Richard Gigli.)

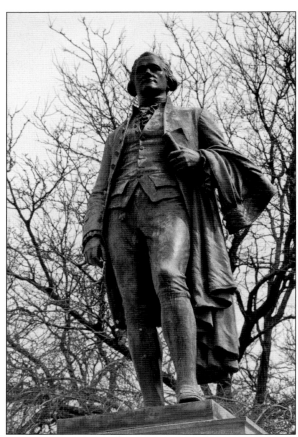

After nearly 100 years in the elements, the statue was in need of an overhaul, and restoration began in 2003. It needed to be cleaned, and 100 years' worth of dirt was removed. A specialist was brought in to replace a long missing cane along with other needed repairs. Finally a coat of wax was applied to protect the figure from the elements. On May 26, 2004, city officials rededicated the statue of Paterson's founding father. (Author's collection.)

This statue of Alexander Hamilton honors his pioneering vision of an industrialized America, a vision which Paterson was among the first to apply. "With the exception of George Washington, nobody did more to bind the 13 states into the powerful unified nation that we know today than Alexander Hamilton," writes Ron Chernow, biographer. (Author's collection.)

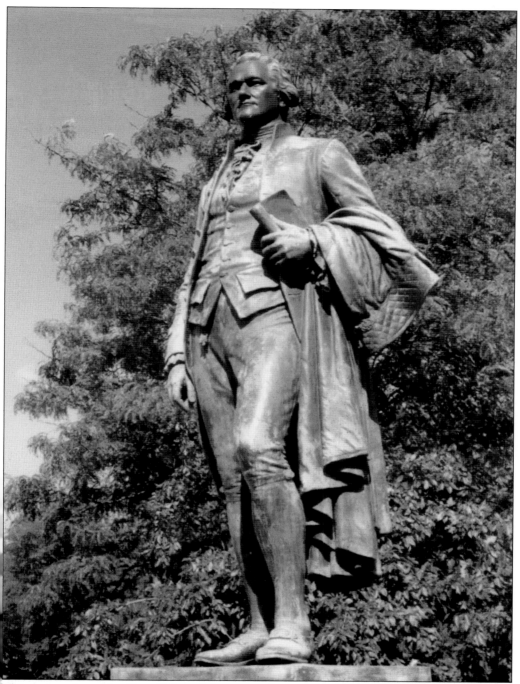

This designation of the Great Falls and the surrounding area as a national historical park preserves the priceless legacy for this and future generations and in the memory of those long gone whose hands and hearts were part of its building. The statue of Alexander Hamilton graces the plaza overlooking the Falls, whose vast power potential prompted him to create the first industrial city of the new world on its banks. (Author's collection.)

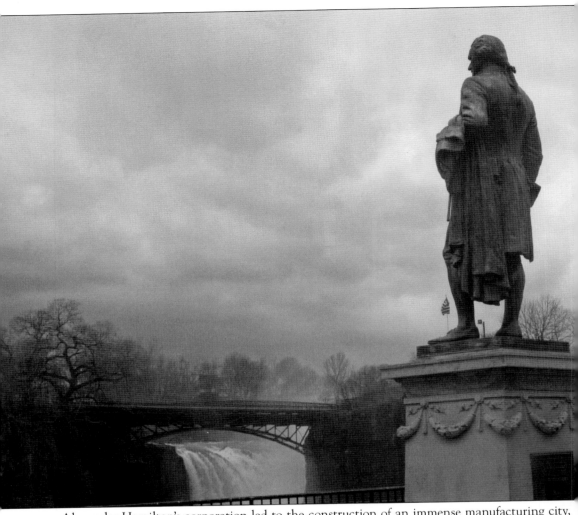

Alexander Hamilton's corporation led to the construction of an immense manufacturing city, with cotton and silk mills and locomotive factories. By 1900, Paterson was the 15th largest city in the United States. Hamilton's statue looks out at an enticing mix of natural sights, a few of them restored, and unrestored factory buildings that in combination with the Falls make a remarkable sight. (Author's collection.)

Three

S.U.M.

In 1791, while secretary of the treasury of the United States, Alexander Hamilton and a group of investors helped promote a private, state-chartered corporation, the Society for Establishing Useful Manufactures (S.U.M.). Wishing to achieve independence from British companies, Hamilton selected New Jersey and the town where he stopped for lunch in 1778. It was through his influence that the directors of the S.U.M. demonstrated the profitability of American manufacturing. Hamilton also selected New Jersey because the legislature of the state was willing to give the S.U.M. many privileges that were not normally granted to private corporations. On November 22, 1791, Gov. William Paterson granted a charter to the S.U.M., and the new town was named for the governor himself.

The land surrounding the Falls was selected for a proposed manufacturing settlement. The Falls' enormous height and the surrounding terrain had characteristics essential for the utilization of waterpower at that time. From the Passaic River, the S.U.M. planned to divert water through a three-tiered raceway system.

The S.U.M. purchased a tract of about 700 acres adjoining the Falls, which had approximately 10 houses, for $8,233.53. The authorized capital of the new company was $500,000. William Duer, the first governor of the S.U.M., developed the initial plan for the Great Falls site—opening the channel above the Falls and building a power and transportation canal all the way to the tidewater at the present site of Passaic, New Jersey.

Harnessing the power of the Falls provided abundant and inexpensive energy to the new manufacturing mills. Utilizing the entire power of a major river, it was the first, largest, and most significant waterpower system in the United States at the time and the incorporation of the oldest town in the nation in which town planning and the development of industry were driven by waterpower.

This is a c. 1846 photograph of the original S.U.M. gatehouse, with the hydroelectric generating plant in the background as viewed from the southwest. This is where the raceway begins. It began as a single canal and by 1838 expanded into a complex system as the mill area grew. The gatehouse regulates the amount of water from the Passaic River into the raceway. Due to the leaking of the reservoir that fed the raceway system, a channel was cut directly from the river in 1838, followed in 1846 by this gatehouse fitter with sluice gates to better control the flow. (Library of Congress Prints and Photographs Division.)

These images show an original manhole cover (above) near the S.U.M. building and the letters S.U.M. in the fence (right) overlooking the waters of the Passaic River facing the Great Falls Generating Station and the Hydroelectric Station. (Above, Library of Congress Prints and Photographs Division; right, Paterson Museum, photograph by Michael Spozarsky.)

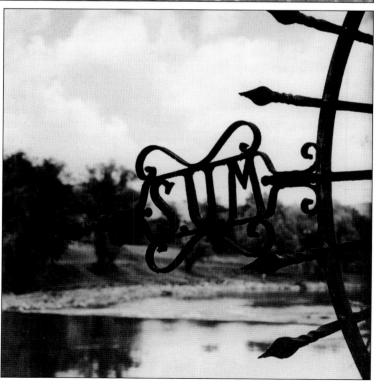

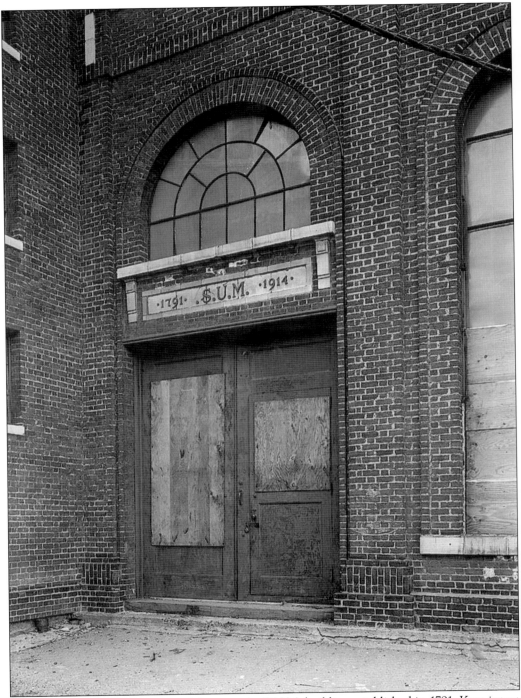

This photograph is of the original doors to the S.U.M. building established in 1791. Kept intact during the renovation of the building in the 1980s, they are still used today by visitors entering to tour the plant. During the summer, the doors are kept open and the roar of the turbines producing energy can be heard outside. (Library of Congress Prints and Photographs Division.)

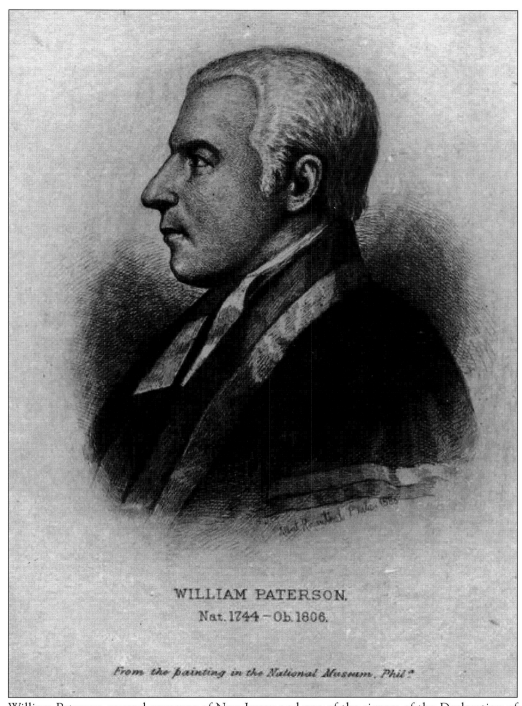

WILLIAM PATERSON.
Nat. 1744 – Ob. 1806.

From the painting in the National Museum, Phila.

William Paterson, second governor of New Jersey and one of the signers of the Declaration of Independence, granted the charter to Alexander Hamilton and his investors for the S.U.M. Because of his generosity, the new city was named for the governor. (New York Public Library Digital Gallery.)

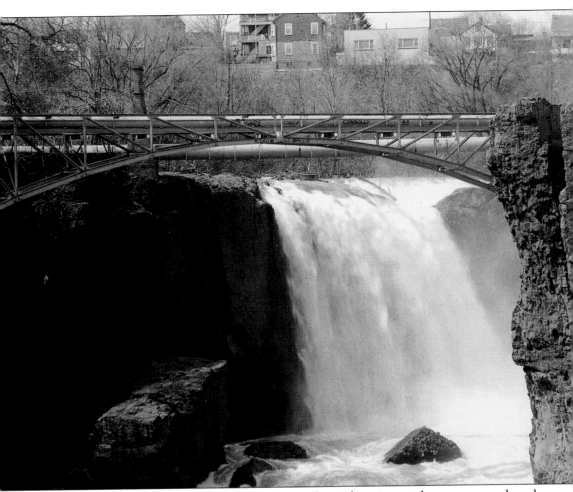

Hamilton envisioned America becoming an industrial nation, with an economy based on manufacturing and trade. With its natural waterpower from the great cataract, the city of Paterson would form the nucleus of his idea and translate dreams into action. (Author's collection.)

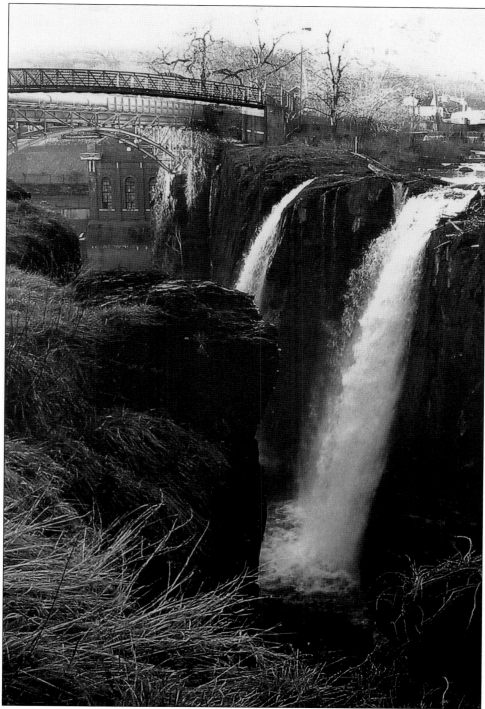

Hamilton selected the land surrounding the Falls for the proposed manufacturing settlement. The enormous height of the Falls and the surrounding terrain had characteristics that were essential for the utilization of waterpower at that time. (Photograph by Richard Gigli.)

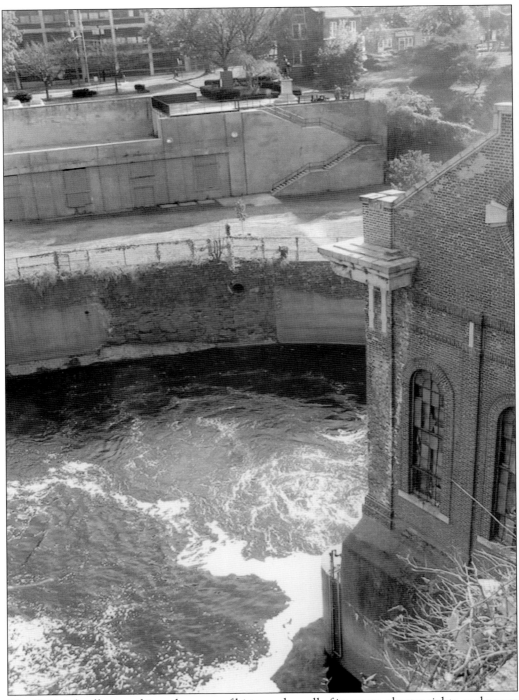

The S.U.M. finally passed into the pages of history when all of its assets, charter rights, and power plants were sold to the city of Paterson in 1945. Throughout its history, the S.U.M. stood as the boldest private enterprise ever conceived in the United States. (New Jersey Park Service.)

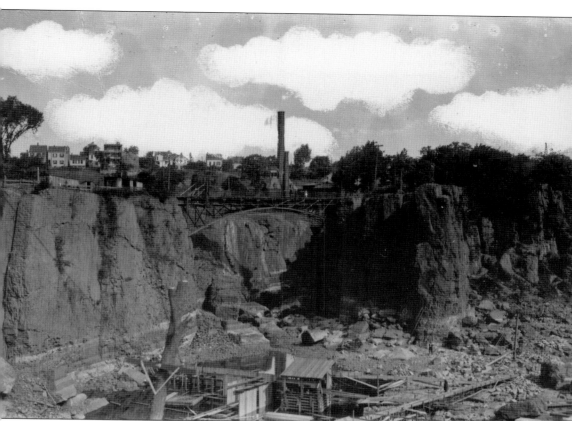

As the call for more efficient and economical energy resounded throughout the district, the S.U.M. gouged out a portion of the cliff adjacent to the Great Falls in 1912 in order to construct a hydroelectric plant. (State of New Jersey, Digital Images collection.)

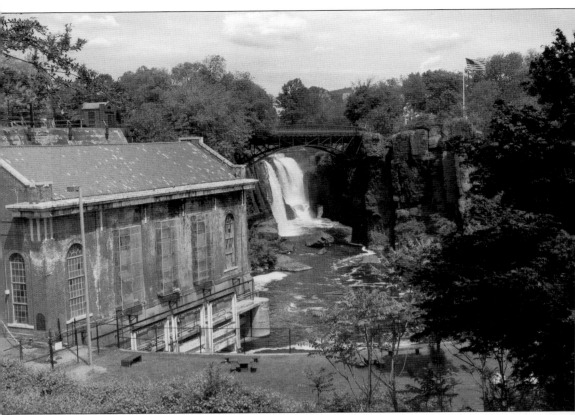

The hydroelectric plant sits below the road at the bottom of the Falls and is best seen from the overlook. Those who wish to walk down two flights of stairs to the water's edge can view it more closely. It is a potent reminder of the great power and strength of industrial architecture. (Author's collection.)

Four

GREAT FALLS POWER RACEWAY SYSTEM

The S.U.M. was organized specifically to develop the waterpower of the Great Falls site. Construction of the raceway system for the direct waterpower to mill sites began in 1792.

While serving as the original superintendent of the S.U.M., Pierre L'Enfant (eventually the designer of our nation's capital at the request of George Washington), designed the first raceway corralling the Falls' power. He was also responsible for developing the concept that would later produce the multi-tiered channel system that would power the upper-tiered mills. L'Enfant's plan took too long—water was not made available to operate the mills by early 1793—so he was replaced by Peter Colt, who got the water flowing to the new factories by 1794 by following a simple and less complicated plan that provided abundant and inexpensive energy to the new manufacturing mills.

Colt's raceway continued to run until 1799. By 1800, the S.U.M. became a power developer and real estate firm. By then, it also became evident that the raceway was too short and would have to be extended to provide water to more mills. From 1800 to 1827, a middle raceway was built beyond the first mill site and lower raceway along Van Houten Street.

Mill activity grew rapidly, and by the end of the second decade of the 19th century, realignment of the raceway also channeled power for the upper-tiered factories. The last modification to the raceway system was made in 1838. From that 1838 modification until the dawn of the 20th century, the raceway and power system were the principal sources driving the industries surrounding the Falls. It has been continuously used since the 1790s. It is a landmark of American mechanical and civil engineering heritage.

The three-tiered raceway system remains substantially unaltered from its 1846 appearance, though the S.U.M. added 2 feet to the dam in 1864 and a concrete sluiceway to supplement the S.U.M. gatehouse at the river entrance.

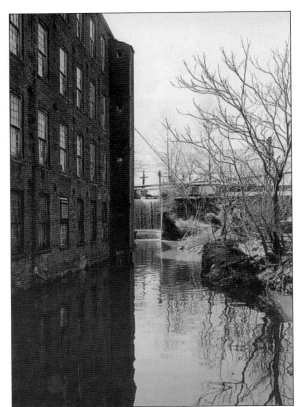

A wooden dam diverted water from the Passaic River above the Falls. From the reservoir, the water flowed through what is today the middle raceway to a flume in the S.U.M. cotton mill and an overshot waterwheel that powered spinning machines. Water flowed from the mill back into the Passaic River through the tailrace or drainage channel. These photographs depict the drop from the middle to the lower raceway, which is behind the Essex Mill on the northwest side of Mill Street. (Both, Library of Congress Prints and Photographs Division.)

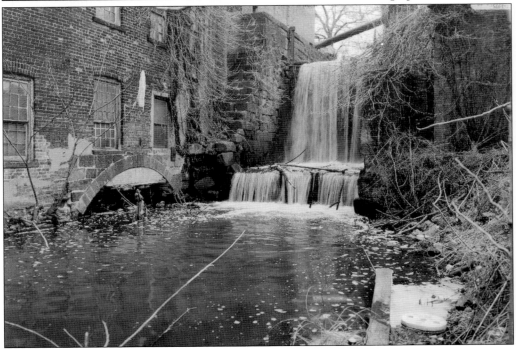

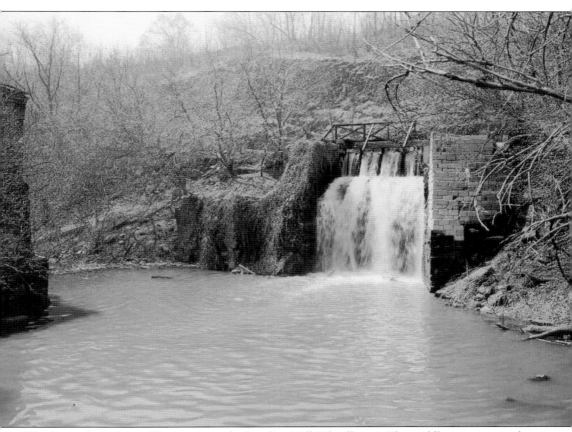

This drop is from the middle raceway at the Ivanhoe Mill Wheelhouse. The middle raceway was the first section of the three-tiered system to be built in 1793. The walls of the races were constructed of brownstone masonry, quarried from the hills nearby. There is a drop of approximately 22 feet between the races and three spillways connecting them. The total length of all the races combined is about 1.5 miles. (Library of Congress Prints and Photographs Division.)

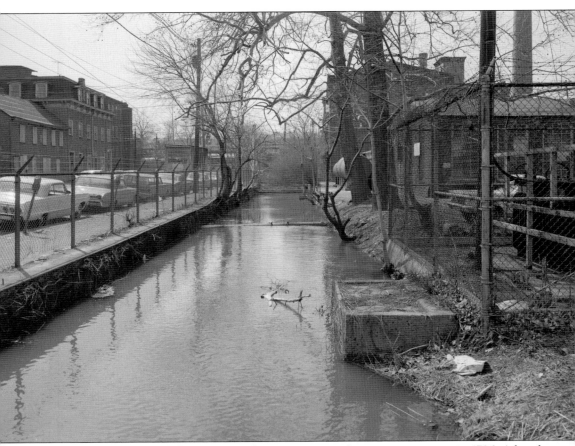

Financial difficulties led the S.U.M. to discontinue manufacturing operations in 1796. After the failure of the corporation's early manufacturing efforts, the S.U.M.'s directors elected to restrict operations to leasing land and waterpower to independent manufacturers. This new incarnation of the company proved far more profitable than the earlier version, and the first half of the 19th century witnessed a revitalization of industry in Paterson. Fueling this was an extension of the middle raceway in 1800 and construction in 1807 of the lower raceway along what is today Van Houten Street. This photograph of the lower raceway, completed in 1807, faces west, where the lower raceway flows back into the Passaic River. This lowest section has served as a drainage canal for the overflow from the middle raceway since the 1790s. (Library of Congress Prints and Photographs Division.)

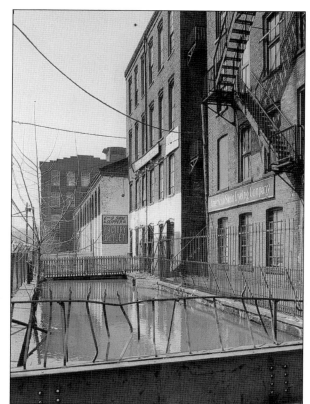

This view shows the lower raceway (right), looking east toward the Harmony and Phoenix mills. An image of the middle raceway (below), with the Ivanhoe Mill Wheelhouse and Grant Locomotive Works on the right, shows the Spruce Street Bridge over the channel. The middle raceway was built soon after 1800. (Both, Library of Congress Prints and Photographs Division.)

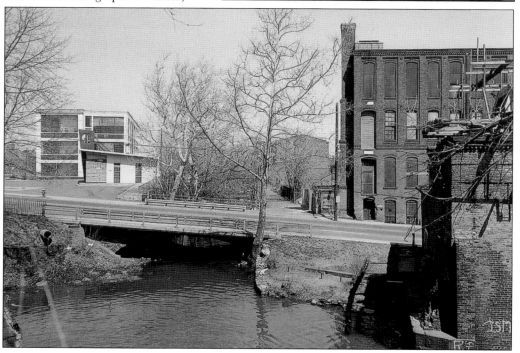

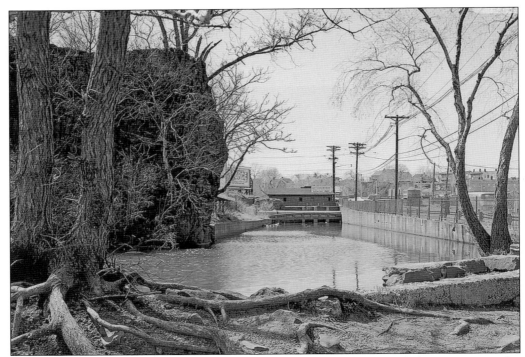

The upper raceway runs from the east toward the S.U.M. gatehouse and the entrance to the power canal system. In 1828, the S.U.M. added to its system of waterworks by constructing a two-tiered upper raceway above Spruce Street, which diverted water from the middle raceway and had spillways that allowed water to flow back to the middle raceway. This was the last of the channels constructed to harness water for the foundries, forges, and mills huddled along its banks. (Library of Congress Prints and Photographs Division.)

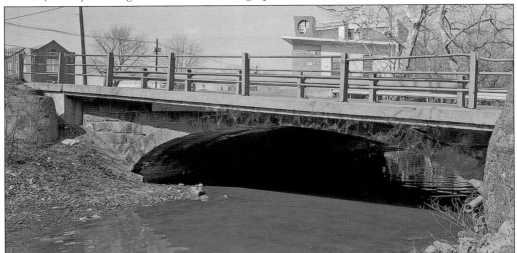

Over the upper raceway is the Spruce Street Bridge. The building located directly across the street was at one time a gas station. The site had long been abandoned until the City of Paterson's Department of Community Development established the Great Falls Cultural Center. The center is now a facility of the Paterson Museum. (Library of Congress Prints and Photographs Division.)

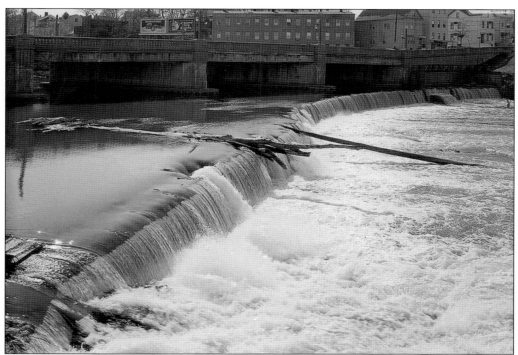

Leakage from the earthen embankment caused the S.U.M. to fill in the reservoir in 1838. A dam built above the Great Falls redirected water through a new channel to the upper raceway. The 1840 Island Dam on the Passaic River was built downstream to divert the river around the tip of the rocks so that water could drop into a parallel tailrace connecting to the new middle raceway. (Library of Congress Prints and Photographs Division.)

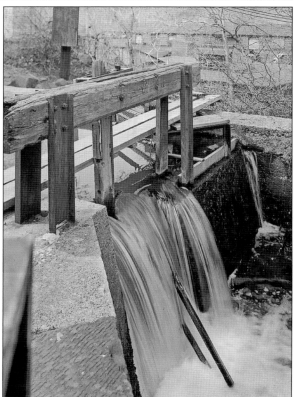

This is a view of the top of the dam that separates the middle and lower raceways. The obvious effect of the dam and raceway was to lower the volume of water tumbling over the Falls. As the number of factory wheels grew, the volume of waste materials finding their way into the stream had a noticeable effect: pollution of the Passaic River was well under way. (Library of Congress Prints and Photographs Division.)

This is the dam between the middle and lower raceways from the upstream side, with the Waverly mill and other buildings of the Textile Printers Complex in the background. Waterpower has been used since ancient times. Paterson's mills originally used waterpower to turn individual waterwheels that supplied power directly to machines through systems of shafts, gears, pulleys, and belts. Only in the 1800s did electric generation become technically possible. (Library of Congress Prints and Photographs Division.)

This is the detail of the mechanism for raising and lowering the level of the spillway between the middle and lower raceways. The spillways allow water to travel to the next level. (Library of Congress Prints and Photographs Division.)

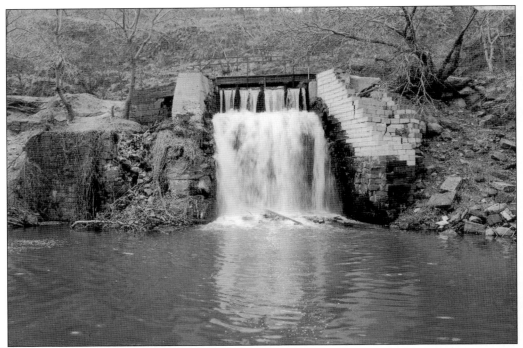

This view above is of the spillway from the upper to the middle raceways located beside the Ivanhoe Wheelhouse Mill. The view below is of the Falls from the middle to the lower raceway with the arch of the Essex Mill tailrace visible on the left. This portion of the Essex Mill dates back to 1856. (Both, Library of Congress Prints and Photographs Division.)

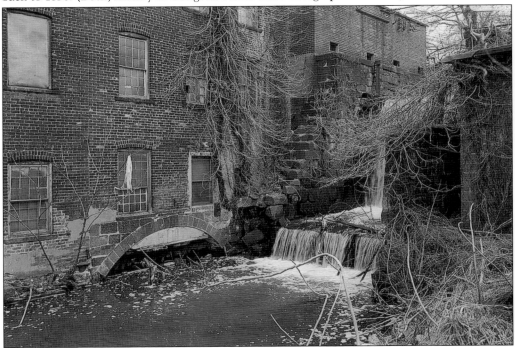

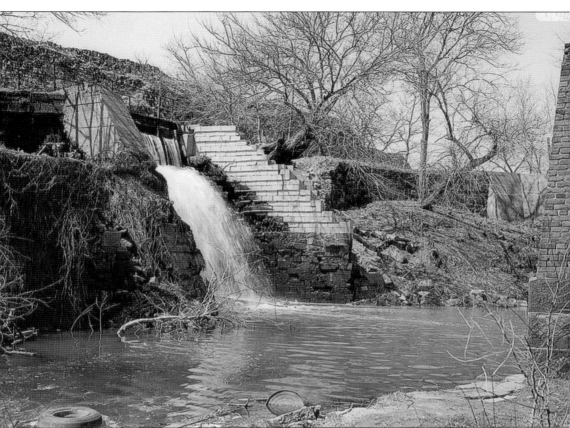

The middle raceway to the lower raceway is shown with the 1856 addition to the Essex Mill visible on the left and the Colt Mill on the right. The spillway from the upper to the middle channels, with the Ivanhoe Wheelhouse Mill on the right, shows the Ivanhoe as the only building remaining from the Ivanhoe Paper Mill Complex. (Library of Congress Prints and Photographs Division.)

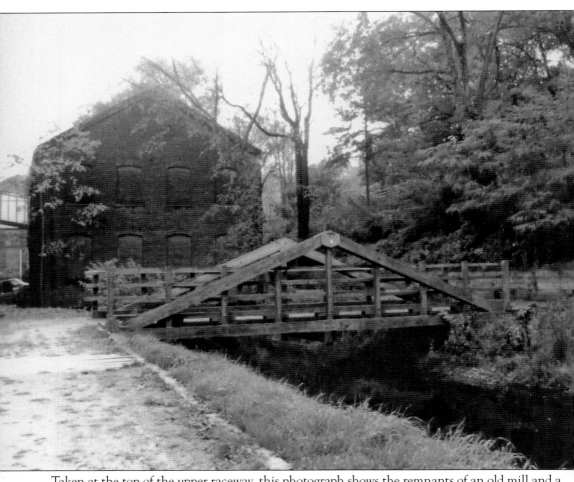

Taken at the top of the upper raceway, this photograph shows the remnants of an old mill and a wooden bridge over the canal. The water raceway system is still visible around the Falls, as are many of the mills built to take advantage of the waterpower. (Author's collection.)

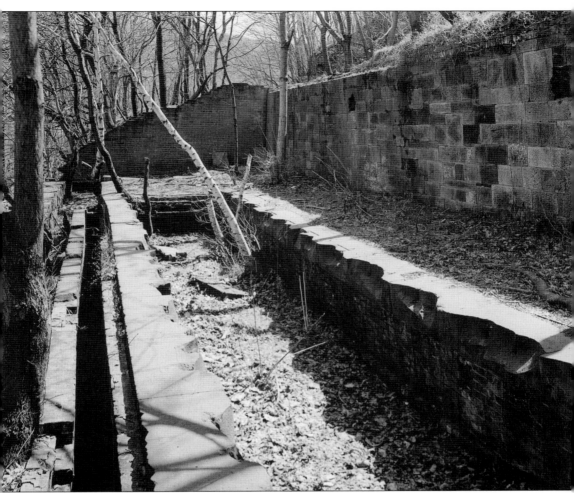

Upper Raceway Park shows a small portion of the colonial aqueduct reservoir system that was developed in Paterson to harness the power of the Great Falls and get the water flowing to the factories in 1794. This canal runs above and parallel to the Ivanhoe Wheelhouse Mill. (New Jersey Digital Highway.)

The Great Falls Raceway and Power System is a recognized historic site (below). The 1.5-mile system built between 1792 and 1838 brought waterpower to Paterson's early industries. Falling water would create a clean power source to make Paterson a major industrial center. There are remains of some of the Ivanhoe buildings between the two raceways as well as the middle raceway flowing beneath the Rogers Locomotive Storehouse. This picturesque setting underwent a $2.1 million restoration to become Upper Raceway Park (above). (Both, author's collection.)

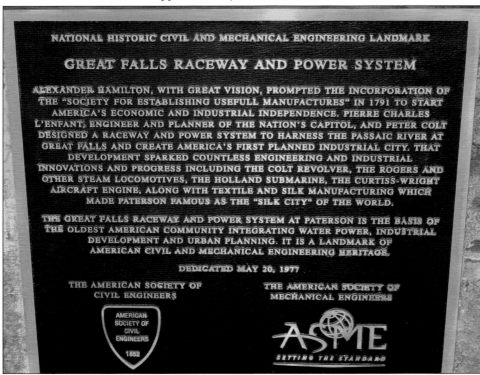

NATIONAL HISTORIC CIVIL AND MECHANICAL ENGINEERING LANDMARK

GREAT FALLS RACEWAY AND POWER SYSTEM

ALEXANDER HAMILTON, WITH GREAT VISION, PROMPTED THE INCORPORATION OF THE "SOCIETY FOR ESTABLISHING USEFULL MANUFACTURES" IN 1791 TO START AMERICA'S ECONOMIC AND INDUSTRIAL INDEPENDENCE. PIERRE CHARLES L'ENFANT, ENGINEER AND PLANNER OF THE NATION'S CAPITOL, AND PETER COLT DESIGNED A RACEWAY AND POWER SYSTEM TO HARNESS THE PASSAIC RIVER AT GREAT FALLS AND CREATE AMERICA'S FIRST PLANNED INDUSTRIAL CITY. THAT DEVELOPMENT SPARKED COUNTLESS ENGINEERING AND INDUSTRIAL INNOVATIONS AND PROGRESS INCLUDING THE COLT REVOLVER, THE ROGERS AND OTHER STEAM LOCOMOTIVES, THE HOLLAND SUBMARINE, THE CURTISS-WRIGHT AIRCRAFT ENGINE, ALONG WITH TEXTILE AND SILK MANUFACTURING WHICH MADE PATERSON FAMOUS AS THE "SILK CITY" OF THE WORLD.

THE GREAT FALLS RACEWAY AND POWER SYSTEM AT PATERSON IS THE BASIS OF THE OLDEST AMERICAN COMMUNITY INTEGRATING WATER POWER, INDUSTRIAL DEVELOPMENT AND URBAN PLANNING. IT IS A LANDMARK OF AMERICAN CIVIL AND MECHANICAL ENGINEERING HERITAGE.

DEDICATED MAY 20, 1977

THE AMERICAN SOCIETY OF CIVIL ENGINEERS

THE AMERICAN SOCIETY OF MECHANICAL ENGINEERS

AMERICAN SOCIETY OF CIVIL ENGINEERS 1852

ASME
SETTING THE STANDARD

Five

EVOLUTION OF THE GREAT FALLS HYDROELECTRIC PLANT

In 1910, under the guidance of the S.U.M., the manufacturers made the switch to electricity, which ran by the hydroelectric station that had replaced the old water mill sites. Blasting directly into the basalt in 1914, the S.U.M. built the hydroelectric generating plant to make more efficient use of the water by turning it into electric energy. The plant represents an evolution in both American engineering and the city of Paterson.

The hydroelectric plant operated from 1914 until 1969. It was decommissioned when repairs were not economically feasible. When oil was cheap, the city neglected its valuable power plant, letting it deteriorate and finally closing it. With the oil crisis of the 1970s, the idea and concept of rehabilitation of the power plant moved forward despite turbulent economic times.

In 1984, the plant was restored with three new handmade replacement turbines, which have a life expectancy of 50 years. The fourth original turbine is still in its historic place. On December 31, 1986, the plant was restarted and today harnesses energy from the Passaic River and its waterfall. The flow of the river generates 11,000 kilowatts per hour, enough electricity for 11,000 homes.

A power purchase agreement dated September 6, 1985, was entered into by the Great Falls Hydroelectric Company and Public Service Electric and Gas Company (PSE&G). The agreement was amended February 9, 1998. Under the amended terms PSE&G continues to purchase all the electrical energy from the facility.

It is the ability of moving water to turn a wheel—or a turbine—that links Paterson's heritage as American's first industrial city with the potential offered for the future. To have this plant in operation preserves the notion that Alexander Hamilton had at the dawn of the Industrial Revolution, thus linking Paterson's past with its present.

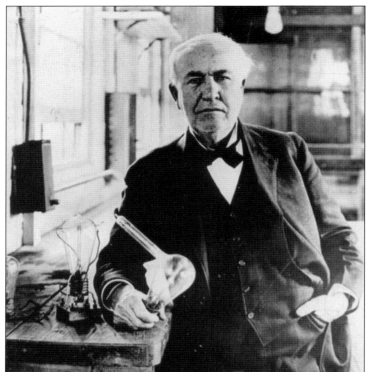

In 1910, the S.U.M. convinced the mill owners to switch to electricity. Thomas Edison's Electric Company drew up plans for a 4,849-kilowatt hydroelectric facility, which operated from 1914 until 1969. The hydroelectric station further increased the power that could be developed at the Great Falls. The early raceway system had wasted much power, while the hydroelectric plant wasted almost none. (Library of Congress, Prints and Photographs Division.)

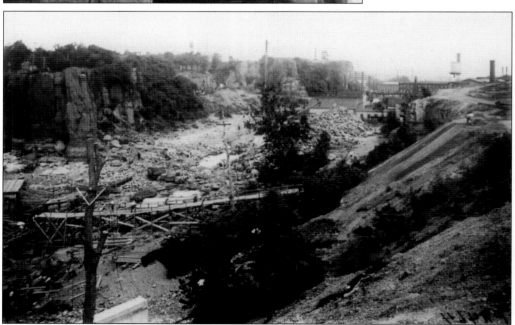

This c. 1913 photograph taken during construction of the hydroelectric plant shows the Passaic River bed upstream from the Great Falls, with part of the crossing bridge on the far left. A walkway runs across the riverbed, and a section of a concrete retaining wall is near the bottom left. (State of New Jersey Digital Images Division.)

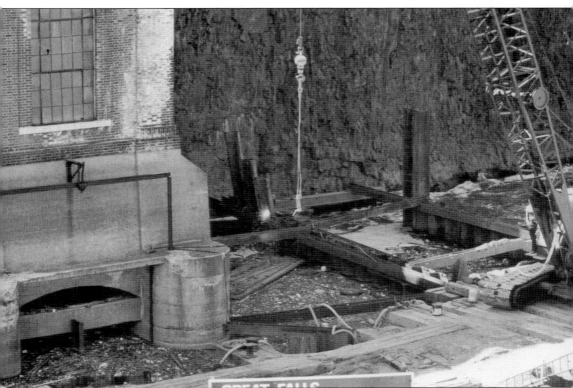

In 1912, the hydroelectric plant and steam plant were built in the gorge of the Passaic River at the basin of the Falls. A steep, sod embankment sloping from the sidewalk toward the level of the large brick building was eventually constructed. After the installation of the plant, the city of Paterson attempted to tax its operation; however, the court ruled in favor of the S.U.M. A similar suit was lost by the city in 1937. The municipal government contended that the S.U.M. forfeited its tax-exempt rights by giving up manufacturing in 1796, leasing out the sites to private concerns, and had already enjoyed many years of special rights. In operation from 1914 to 1969, the plant closed because of flooding and deterioration over the years. Restoration began in 1984, and the plant went back into operation on December 30, 1986. It is independently operated, and average annual production is a pollution-free 33 million kilowatts. (Author's collection.)

On June 29, 1987, government officials of the city of Paterson rededicated a refurbished hydroelectric generating plant meant to help ease the nation's dependence on foreign oil (below). Frank X. Graves Jr. (left), mayor of Paterson and a state senator at the time, hailed the restoration of the plant, stating that "we were rededicating ourselves to the principles our country was founded on, in addition to taking our natural resources and expanding them, and still enjoying what America is all about, the beauty of the Falls." (Both, author's collection.)

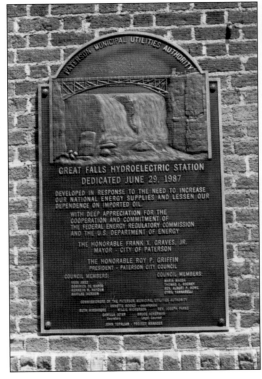

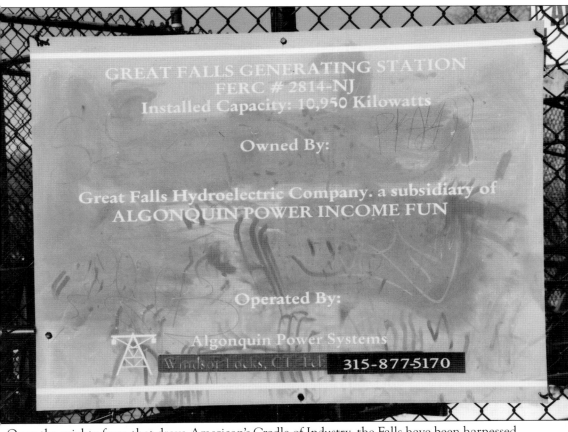

GREAT FALLS GENERATING STATION
FERC # 2814-NJ
Installed Capacity: 10,950 Kilowatts

Owned By:

Great Falls Hydroelectric Company, a subsidiary of
ALGONQUIN POWER INCOME FUN

Operated By:

Algonquin Power Systems
Windsor Locks, CT Tel. 315-877-5170

Once the mighty force that drove American's Cradle of Industry, the Falls have been harnessed once again at the hydroelectric plant located at their jagged shoulder. The plant is now operated for the Municipal Utilities Authority (MUA) by the Algonquin Power Company of Oakville, Canada. To have this plant in operation preserves the notion that Alexander Hamilton had at the dawn of the Industrial Revolution; using the power of the Great Falls links Paterson's past with its present and eventually to the Passaic River's future. (Author's collection.)

The Paterson Municipal Utilities Authority (MUA) was created on June 29, 1981, to reactivate the hydroelectric plant at the Great Falls. On June 7, 1982, the MUA acquired the plant and around 10 acres. With a grant from the U.S. Department of Energy, the MUA and the city of Paterson planned renovations and secured an operating license. The MUA solicited proposals from private energy developers to invest capital and operate the plant under a long-term lease. All work was to be done in accordance with historical standards. The renovated plant went on line in December 1986 with a capacity of 10,950 kilowatts, a 125 percent increase over the original output. Above, this weathered sign was installed by the city of Paterson prior to Pres. Gerald R. Ford's visit to the Falls. The sign on the building below, located next to Overlook Park and across the street from the Great Falls Cultural Center, lists the various city offices housed there. It also shows the logo for the historic district. (Both, author's collection.)

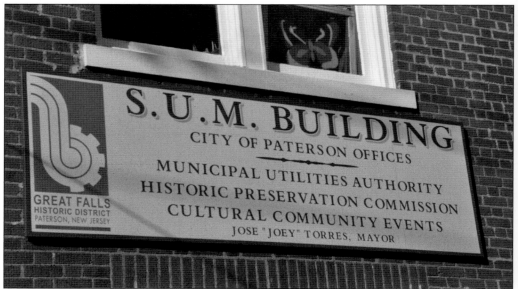

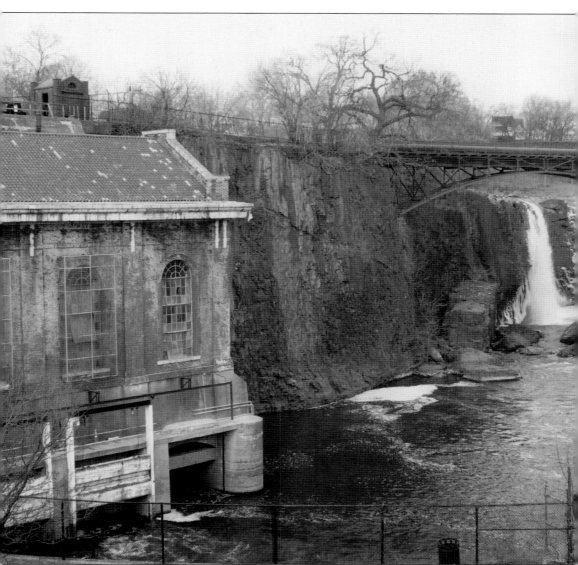

The S.U.M. Hydroelectric Plant was constructed to meet the electrical power needs of the mill and factory owners and tenants in the Paterson area. It superseded the power canal system and is situated on a narrow neck of land in a bend in the Passaic River. The plant operated under a normal head of 69 feet and incorporated four horizontal shaft turbines made by S. Morgan Smith. The Passaic River and the dramatic 77-foot drop at the Great Falls provides the energy to turn a wheel or turbine and, depending on river flows, can, at peak capacity, employ the plant's three turbine generators, producing up to 10.5 megawatts per hour in the PSE&G power grid. (Author's collection.)

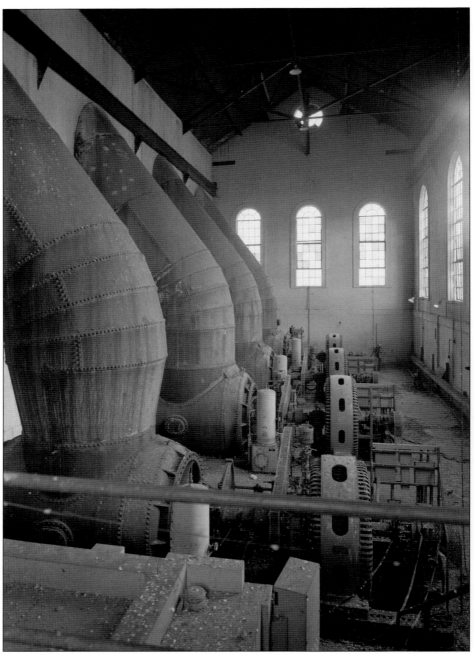

The building hugging the cliff contained four giant-scaled turbines that once roared energy to the mills beckoning for life-giving energy and generating 21 million kilowatts annually. The installed capacity for the plant was 4,849 kilowatts (6,500 horsepower). The turbines consisted of three units of 1,720 horsepower and one unit of 1,390 horsepower at 70 feet head. The units installed in 1914 were equipped with wicket gates for unit flow control. Hydraulic governors regulated unit speed. Steel slide gates, manually controlled, provided positive upstream closure. (Library of Congress Prints and Photographs Division.)

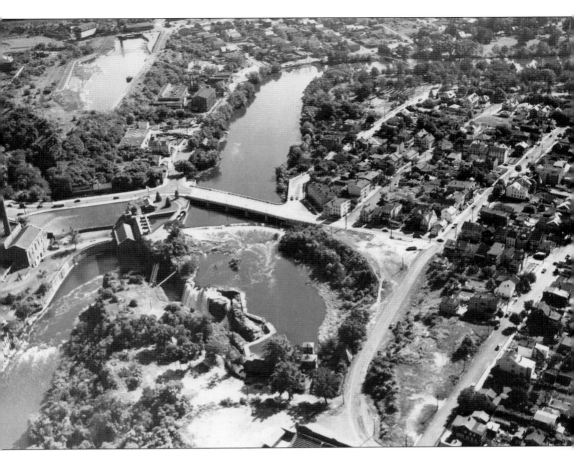

This is an aerial view looking northwest with the Great Falls of the Passaic River and hydroelectric plant at left. The hydroelectric plant further increased the power that could be developed at the Great Falls, which supplemented the function of the raceway system and increased the power available. After restoration, the station went back on line at 7:43 p.m., December 31, 1986. (Library of Congress Prints and Photographs Division.)

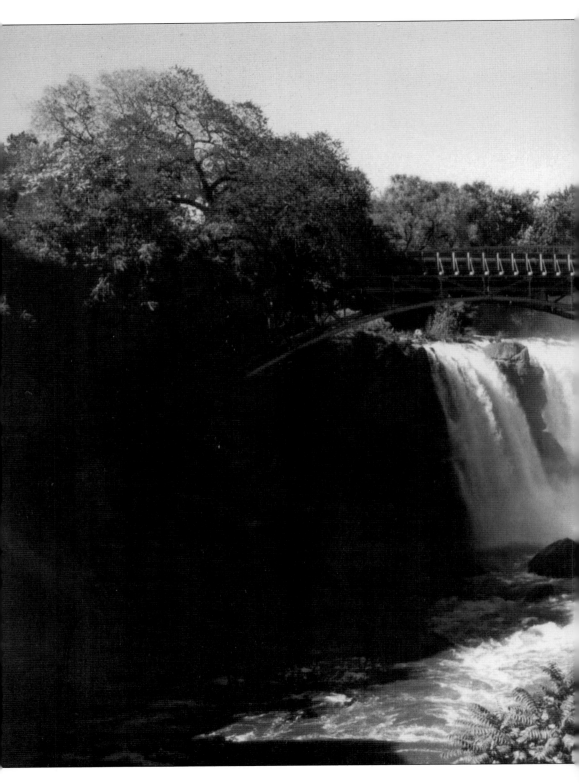

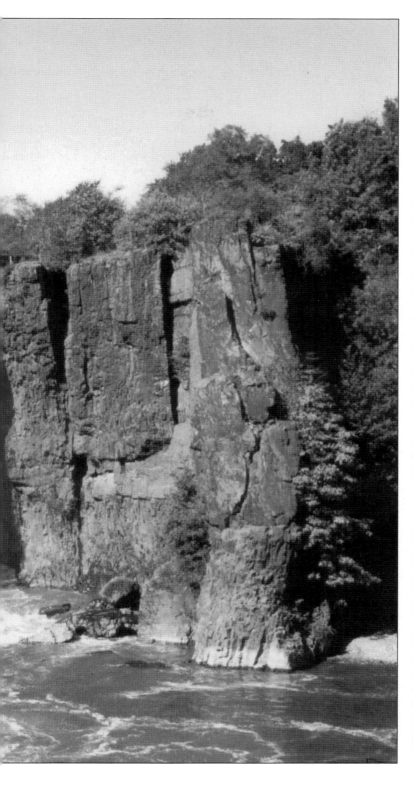

The Falls can be viewed from Haines Overlook Park to the south and Mary Ellen Park to the north. Where McBride Avenue and Wayne Avenue cross the river above the Falls, one can drive by and view them clearly. An exciting overlook point where visitors can feel the spray and view the famous Falls rainbow is the footbridge over the gorge. On March 30, 2009, Pres. Barack Obama signed the Omnibus Public Lands Act of 2009, which included the designation of 35 acres of city land as Great Falls National Historical Park. This act is part of an omnibus parks and historic preservation bill that the president called "the most important pieces of natural legislation in decades. Passage of this act not only honors and preserves Paterson's past but it will also brighten its future". (Author's collection.)

The Great Falls hydroelectric plant will soon be fitted with solar panels to increase its energy efficiency. Installing the panels on the roof will enable the plant to generate even more electricity. Investigation of the Falls as a potential source of hydroelectric and solar power is a renaissance in itself of the hope and vision Alexander Hamilton had when he looked upon this great waterway more than 200 years ago. (Author's collection.)

Six

SAM PATCH, THE JERSEY JUMPER

Sam Patch, born in 1799 in Massachusetts, moved to Pawtucket, Rhode Island, in 1807, where he began working as a child laborer spinning cotton in a mill. During his leisure time, he would jump from a bridge spanning the Pawtucket River just for fun. While still a teenager, he moved to Paterson and started a cotton mill with a Scotsman named Kennedy. When Kennedy ran off with all of their profits, Patch found fame and fortune by leaping from high places. Jumping at first as a sort of social protest, he attracted crowds for his stunts and found he could make a lot of money by risking his life, so he turned it into a full-time pursuit. He attempted to jump the Great Falls several times, and he was caught by the local police before one of the leaps and detained overnight.

On September 29, 1827, a new wooden preconstructed bridge was being drawn across the rocky gorge above the Falls. As it was being swung into place, Sam Patch, clad only in his underwear, with crowds of onlookers on either side of the Great Falls, dashed out from behind a large dead oak tree at the top of the Falls. He leapt from a rock jutting out over the roaring Passaic River. Down he went, feet first, arms outstretched (like a statue), 80 feet, against the backdrop of the Falls. He emerged a few seconds later to raucous cheers from the crowd. Patch got his first taste of applause and liked it. He became the hero of the hour. His cryptic slogan: "Some things can be done as well as others." He repeated this jump at least two more times and became known in the press as Patch, the Jersey Jumper.

THE WONDERFUL LEAPS

OF

SAM PATCH

Sam Patch started jumping from high places just for fun. Once the Paterson resident discovered he could make a living at it, he quickly became "The Jersey Jumper." Most of Patch's friends thought he was kidding: sure he craved attention, but jump over the Passaic Falls? After a September 1827 leap into the abyss, he went again on August 2, 1828, and people wondered why a man should carry on so unless he was "unhinged." Yet Patch had immortalized himself. This illustration depicts the daredevil Sam Patch, whose fatal leap in 1829 took place over the Genesee River's Upper Falls. He is shown jumping from a platform while a crowd looks on from the town below. (Rochester Public Library Local History Division.)

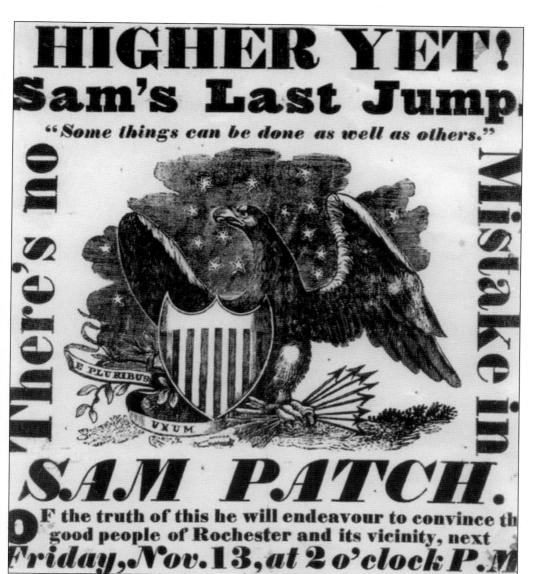

HIGHER YET!
Sam's Last Jump.
"Some things can be done as well as others."

There's no Mistake in SAM PATCH.

F the truth of this he will endeavour to convince th good people of Rochester and its vicinity, next Friday, Nov. 13, at 2 o'clock P.M

Sam Patch's first jump into the Genesee River on November 6, 1829, raised little money and a small crowd so he decided to repeat the feat on November 13, 1829, while increasing the height of the jump to 125 feet by constructing a 25-foot stand. This is a reproduction of an 1829 broadside advertising what would become Sam Patch's final leap, from the Upper Falls of the Genesee River, which ended in tragedy on Friday, November 13, 1829. In the center is an illustration of an eagle and shield on a field of stars. (Rochester Public Library Local History Division.)

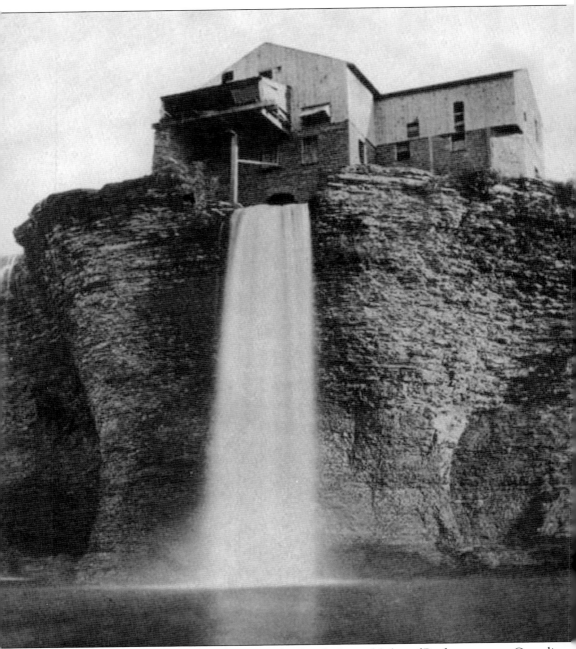

This sawmill belonged to Thomas Parsons, lumber dealer and father of Rochester mayor Cornelius Parsons. The mill was located at the Upper Falls of the Genesee River and the scene of Sam Patch's leap into the waterfall. Accounts from the crowd differ on whether he actually jumped or fell, as he did not achieve his normal feet-first vertical entry. A loud impact was heard but he never surfaced. Patch's frozen body was found in the ice early the next spring. (Rochester Public Library Local History Division.)

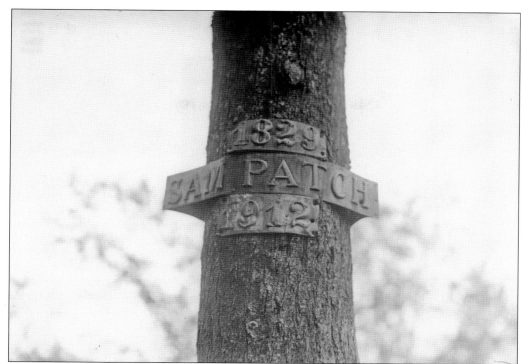

On Tuesday, March 23, 1830, the *Anti Masonic Enquirer* listed Sam Patch's obituary, which reads, "The body of this unfortunate man was found near the mouth of the Genesee River after being in the water about five months. The body was in a state of perfect preservation, not all bloated or in the least changed. The black handkerchief was tied around his loins as when he made his fatal jump." His grave and headstone are at the Charlotte Cemetery in Rochester, New York, and this photograph is a close-up view of a marker on a tree near the grave. (Above and right, Rochester Public Library Local History Division.)

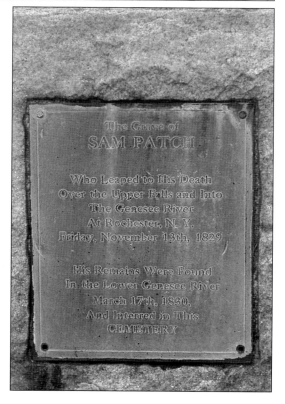

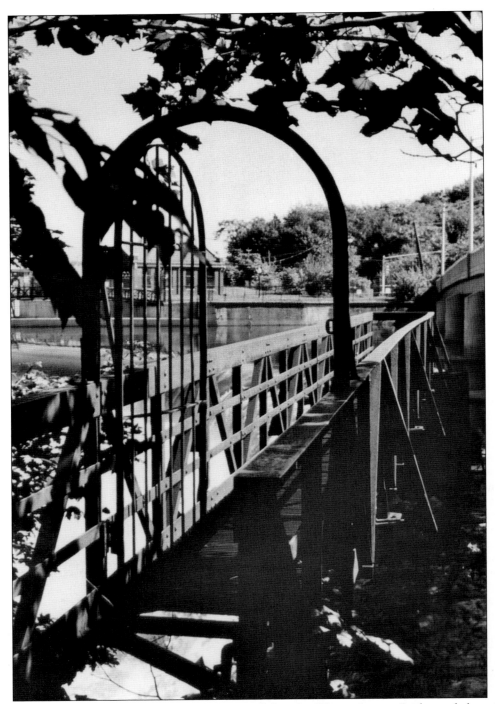

This gateway leads to an overlook which lies parallel to the Wayne Avenue Bridge and abruptly ends out over the river. From its tip, the view looks out toward the dam on the Passaic River just before the water cascades over the rocks at the head of the Great Falls, supplying power to the hydroelectric plant. (Author's collection.)

Seven

MILLS, REVOLVERS, LOCOMOTIVES, AND A SUBMARINE

While the nation was expanding its territorial boundaries, Paterson entered its golden age. The S.U.M. sold its land and leased its power to industries flocking to the Falls. Early in the 19th century, America's industrial saga unfolded in Paterson more prosperously and varied than in other emerging manufacturing districts because of the unique chemistry and abundance of inexpensive crucial energy provided by the Falls.

Cotton was the first crop to dominate the burgeoning manufacturing community. By 1825, eighteen Paterson factories used 600 bales of cotton to produce more than 1.5 million pounds of cotton yarn and 3 million yards of fabric. Peter Colt's son John further strengthened the already staggering statistics for the industry by introducing his revolutionary cotton duck and sailcloth in 1821. Within a decade, all sails for the U.S. Navy were made in Paterson.

Samuel Colt challenged his mechanical ability and inventiveness in 1836 to create the revolver later credited with having "won the West." Not meeting with the national acclaim Colt had hoped to receive, the novel revolver lay dormant until the Texas Rangers placed an urgent order for dozens of Colt revolvers to use against the Mexicans. Since his Paterson gun mill was no longer financially lucrative and closed in 1842, he teamed with his friend Eli Whitney Jr., who provided manufacturing space at his factory in Connecticut.

The ensuing decade witnessed the birth of Paterson's two titan industries: locomotives and silk. In the early 1840s, George Murray and John Ryle, known as the fathers of the silk industry, founded the Pioneer Silk Company. About the same time, in 1835, the young machinist Thomas Rogers broadened his manufacturing scope by producing the nation's newly developed giant workhorses, steam locomotives.

John P. Holland, a schoolteacher by profession, began designing submarines, building and launching the first practical submarine in the Passaic River in 1878. Of all his crafts, No. 6 was his most successful. It carried a crew of 15 and had a torpedo tube in the bow. The U.S. Navy bought the Holland No. 6 on April 12, 1900, and it was commissioned on October 12, 1900.

Driven by the ambition, imagination, and determination of its leading citizens to realize the American Dream, Paterson forged into an industrial showcase. Down the river from the Great Falls is the Allied Textile Printer (ATP), a saw-toothed building. The ATP site is a key property in the Great Falls Historic District. It was one of the first locations developed by the S.U.M. and home to a number of mills, including Samuel Colt's original gun mill. (Paterson Museum.)

The Union Works building is one of the oldest mill sites in Paterson. It was originally constructed in 1890 as a locomotive manufacturing mill and then converted to ribbon manufacturing in 1916. In the first half of the 19th century, the mill housed a button factory and various other enterprises in addition to being the site of the first silk-processing machinery factory in the city. (Library of Congress Prints and Photographs Division.)

The only remnant of the once flourishing mills is this building still known as the Todd and Rafferty Mill. The mill is representative of many of the mill buildings in the historic district. Probably designed as a woolen mill, the original structure operated for many years as a cotton mill before undergoing extensive renovations and being converted to a manufacturer of machinery. While structures have existed on the site of the Todd Mill since before 1915, the present building dates from the 1870s. Its greatest prosperity occurred during the second half of the 19th century, when it was known throughout the nation and the world as a producer of machinery, stationary and portable steam engines, and boilers. It is also where the Holland submarine was assembled. (Paterson Museum.)

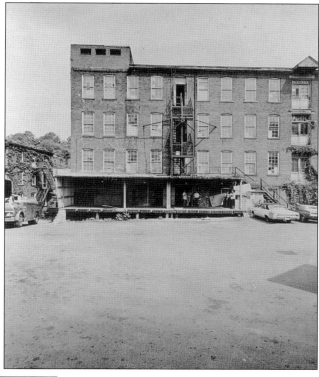

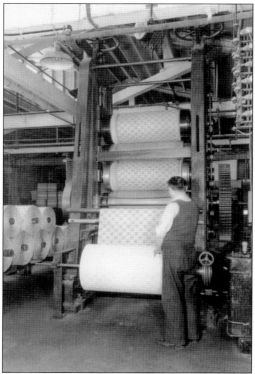

Nestled at the base of the upper raceway, the Ivanhoe Mill Wheelhouse, constructed in 1865, provided power to the Ivanhoe Paper Mill Complex, a large paper manufacturing establishment. It is the only part of the facility still in existence and houses a 200-horsepower vertical turbine as well as two smaller turbines, which powered William Butler's world-famous complex of 10 paper mills that produced paper for the foremost publishers in the country, including the American Bible Society. In this photograph continuous roll paper is being made. (Paterson Museum.)

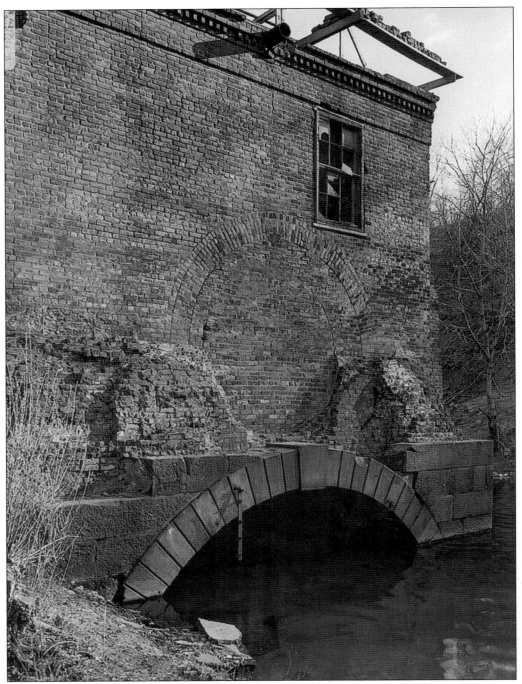

This photograph shows the north side of the Ivanhoe Mill Wheelhouse, including the cornice detail and the arch over the tailrace. It is part of the ruins of the Dyeing and Bleach house. The Rogers Locomotive and Machine Works Fitting Shop is behind the Ivanhoe. The round brickwork on the side of the wheelhouse facing the spillway indicates where the flume ran that brought water from the upper raceway into the waterwheel. (Paterson Museum.)

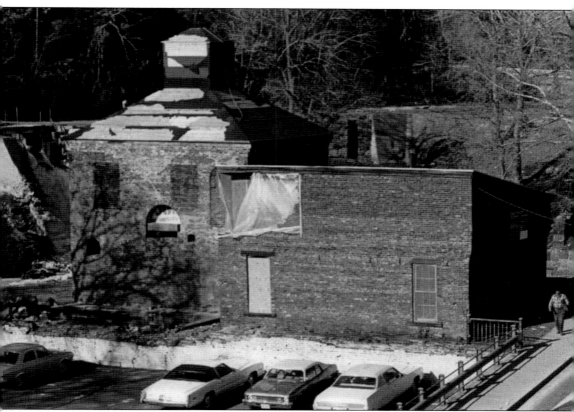

Of the 10 Ivanhoe Paper Company's original buildings, the Ivanhoe Wheelhouse is the only one that still remains intact today, sitting next to the spillway between the upper and middle raceways. It produced writing paper and tissue. Presenting a very imposing appearance, the Ivanhoe was built of cut and dressed sandstone with turreted towers. It was restored in 1981, minus the wheelhouse and turbine. It has been used over the years by various organizations and most recently by the Paterson Reading Group, who held a discussion on the epic poem *Paterson* by William Carlos Williams. (Paterson Museum, photograph by Michael Spozarsky.)

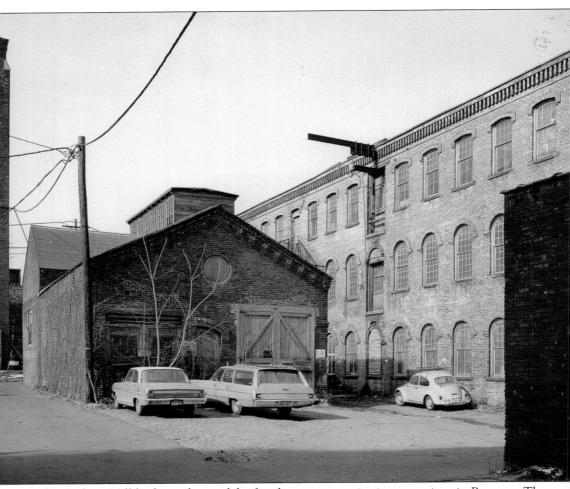

The Godwin Mill lot housed one of the first large cotton spinning operations in Paterson. The mill remained in operation until 1848 when it was destroyed by fire. Nine years later, a new building was constructed on the ruins of the old mill and stands today at Market and Mill Streets. (Paterson Museum, photograph by Michael Spozarsky.)

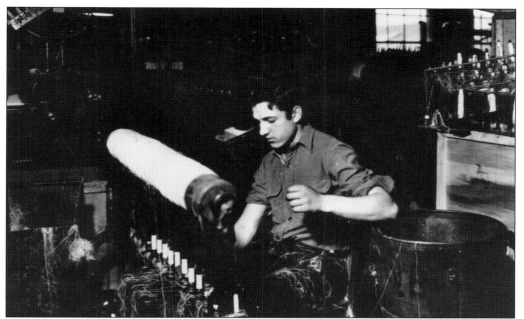

Paterson's factories turned out a great variety of silk products, but their principal output was in ribbons or "plain goods," and broad silk, a wide fabric without a woven-in pattern, used for dresses, underwear, and ties. Paterson produced outstanding silks in huge quantities, and over half of all silk fabric made in the country was produced in Paterson. (Paterson Museum.)

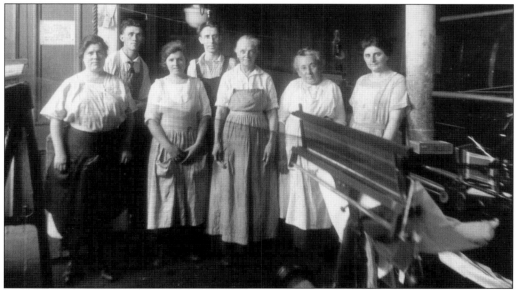

Immigrants flowed into the silk plants. Mills employed almost 28,000 workers. They offered a hard way to make a living: hours were long, 55 per week, from 7:00 a.m. until 6:00 p.m. and a half-day on Saturday. Wages were at the bottom of the list for industries, and fines by the employer nibbled away at workers' already low earnings. An Irish woman who wove in a Paterson ribbon plant in the early years claimed that workers lost a nickel with each trip to the bathroom. (Paterson Museum.)

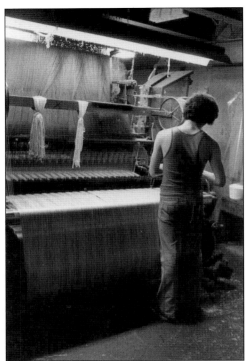

The glamorous silk that issued from Paterson came out of workplaces that were dimly lit and unhealthy. The high-pitched squeal of metal on metal was literally deafening and resulted in intense anguish and even hearing loss. After a while, the rhythm became part of the workers' routine. That was the reason why singing became a part of their work experience. (Paterson Museum.)

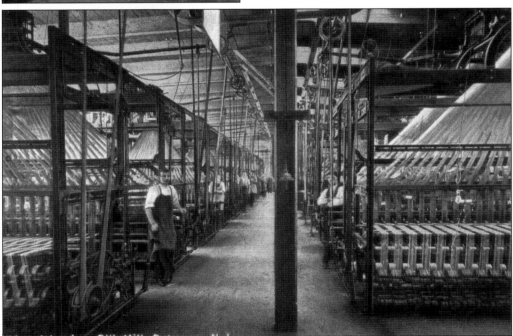

The power loom came to silk manufacturing only in the 1870s. Equipped with an automatic device that stopped the loom when thread broke, the new loom could be attended by women and girls, a less expensive and initially more manageable source of labor. Ribbon weavers made the narrow and often fine silk used for ties, labels, and hatbands. (Paterson Museum.)

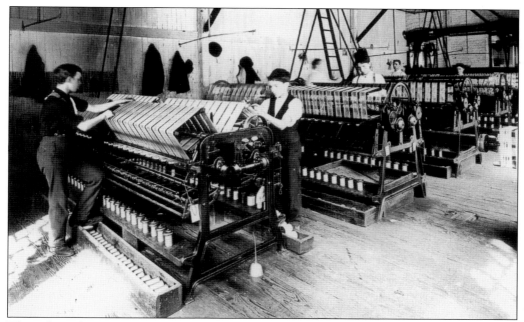

Throughout the 1890s, some hand loom ribbon weavers still worked the old way. But by 1900 or 1905 at the latest, the hand loom had disappeared in Paterson. By using the latest technology, Paterson's manufacturers captured markets from the less-mechanized European silk industry and also attracted capital away from Paterson's older industries. By 1900, they had succeeded in making Paterson into the "Silk City," the "Lyon of America." But new technology did not totally transform the workforce because the habits and attitudes of the hand loom weaver were difficult to overcome. By causing trouble they could maintain the value of their skills so as not to be completely replaced by the modern power loom. (Both, Paterson Museum.)

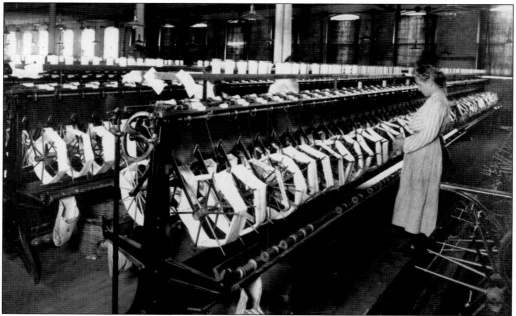

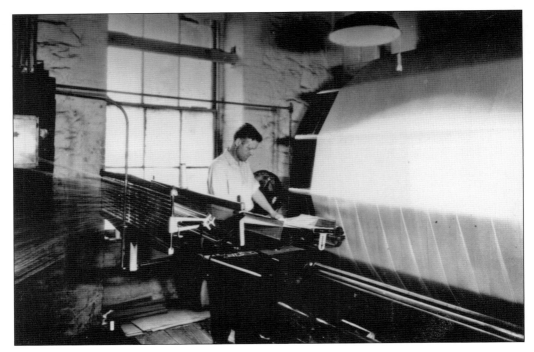

Paterson was essentially an immigrant town; more than half its 1900 population of around 105,000 were first- or second-generation Americans. The older stock came from Britain, Germany, and Ireland, while newer arrivals, received with little enthusiasm by their predecessors, were from Italy and Eastern Europe. (Both, Paterson Museum.)

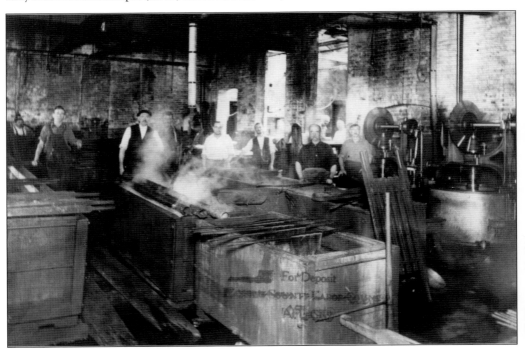

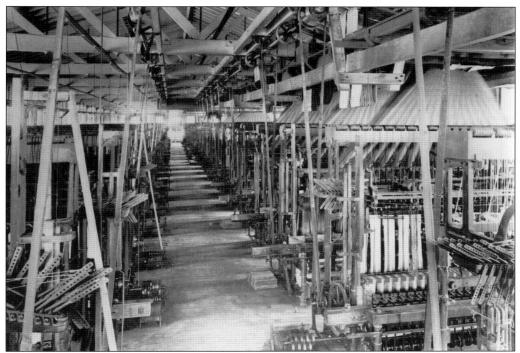

By the 1880s, Paterson was called the Silk City. Every stage of production, except growing the silkworms, took place in Paterson, and silk continued as a prominent industry into the 20th century. In fact, the famous silk workers strike of 1913 took place when the industry was still vital to the city. Silk ceased being important to Paterson after synthetic fibers were developed. (Both, Passaic County Historical Society.)

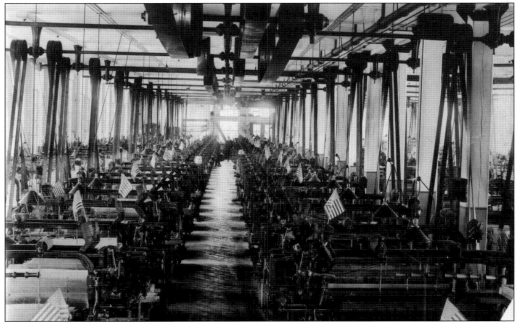

In 1832, there were 20 cotton mills. Before that period, manufacturing was confined chiefly to cotton. By 1814, a new cotton product, cotton duck for sailcloth, previously made entirely by hand, was manufactured on a power loom. In the 1830s, machinery especially for silk began to supersede cotton in importance. According to a government report in 1919, the chief source of fatigue in silk weaving was not the physical work involved but the tension of being watched and constantly on the alert. It was very difficult to tend four looms at one time. When threads broke, looms did not stop automatically, making repairs a huge time factor. (Both, Passaic County Historical Society.)

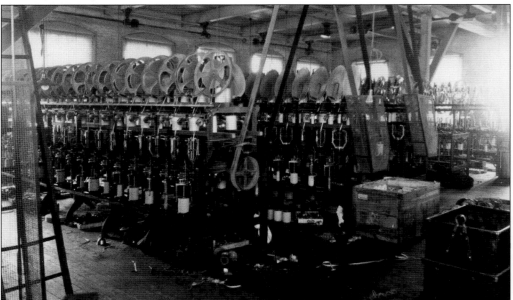

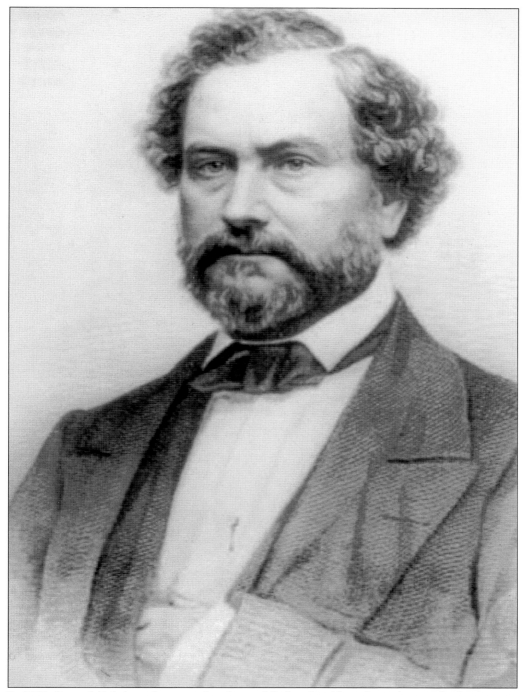

In 1836, Samuel Colt brought to market the world's first fixed barrel, revolving cylinder firearm. Built at the Patent Arms Company of Paterson, the revolver gained fame when it was adopted by the Texas Rangers. Called the Colt Paterson, it was the first revolver Colt produced after obtaining a patent and was manufactured in Paterson. (Paterson Museum.)

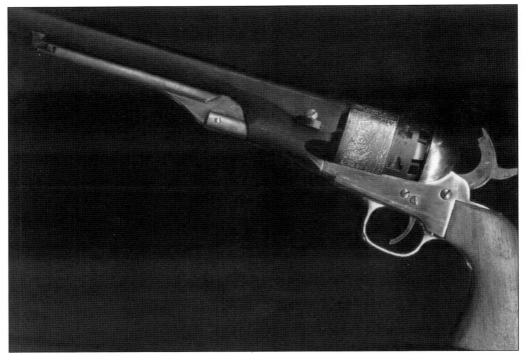

The Patent Arms Company failed in 1842, possibly due to the high price of the Paterson revolver (around $50) and the fact that in the pre–Civil War days the need for a higher firepower hand weapon was not widely appreciated. In 1846, Capt. Samuel Walker of the Texas Rangers paid for his own transportation to meet with Colt in New York City. Walker had used the Paterson revolver on numerous encounters and had ideas for several improvements. He was able to talk Samuel Colt into designing a new pistol incorporating his innovations. (Texas Rangers Hall of Fame and Museum, Waco, Texas.)

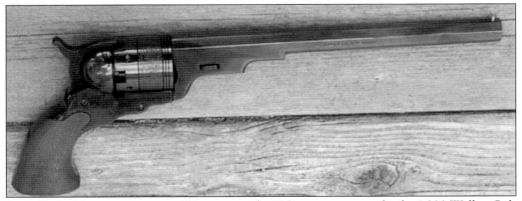

In 1847, the Mexican-American War generated a U.S. government order for 1,000 Walker Colt revolvers. Since his Paterson factory had closed, Colt enlisted the help of Eli Whitney Jr., who manufactured 2,000 of the Walker revolvers, with Colt making $10 per gun. Colt was able to use his profits to establish the Colt Patent Firearms Company in Hartford, Connecticut. He continued to innovate and in 1873 produced what is probably his most famous handgun, the Single Action Army. This was one of the most prevalent firearms of the Old West and earned the nickname the "Equalizer." (Texas Rangers Hall of Fame and Museum, Waco, Texas.)

The Patent Arms Manufacturing Company constructed the Gun Mill, one of the oldest structures in the historic district, in 1836. It was a four-story brownstone structure with a central projecting stair tower. A weather vane in the shape of a gun capped the six-story cupola bell tower, and encircling the factory was a picket fence with each picket depicting scaled versions of the Colt revolver. In 1844, John Ryle and George Murray began to manufacture silk in the structure. Today only two stories remain with all the original walls intact. The heavy wall directly south of the Gun Mill fronting on to the raceway may date to the 1820s or 1830s. (Paterson Museum.)

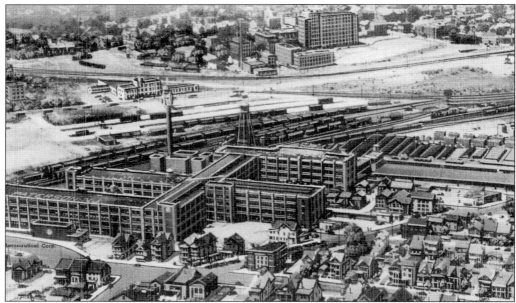

The Wright Aeronautical Corporation was established in Paterson in 1920 and lasted until 1945. It manufactured the single air-cooled Wright Whirlwind J-5C nine-cylinder radial engine that powered Charles Lindbergh's famous *Spirit of St. Louis* flight from New York to Paris on May 20–21, 1927. It was probably one of Paterson's major success stories. In 1929, the plant produced more than 6,000 engines. Paterson remained an important industrial center throughout the 1900s. In fact, many Paterson factories contributed to the production of aircraft engines up through World War II, helping the United States secure victory. On the 58th anniversary of Lindbergh's flight, a plaque was dedicated at the factory on Lindbergh Place (formerly Lewis Street) in a ceremony with Paterson mayor Frank X. Graves Jr. and Congressman Robert A. Roe while a vintage aircraft flew overhead. (Both, Paterson Museum.)

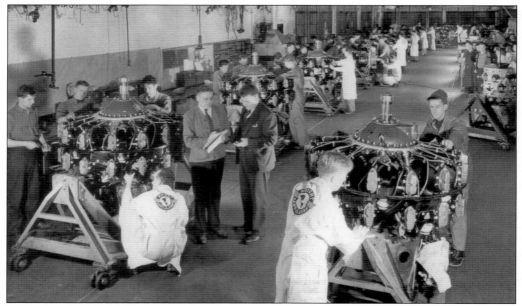

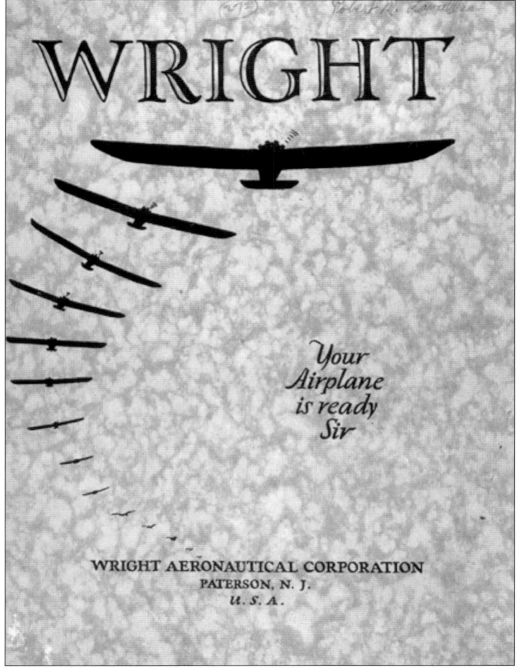

WRIGHT

Your Airplane is ready Sir

WRIGHT AERONAUTICAL CORPORATION
PATERSON, N. J.
U. S. A.

The Wright Company catalog (1927) included a great deal of information about the production, specifications, and use of the company's airplanes, made for both civilian and military purposes. In describing the newest whirlwind engine, the catalog states that Charles Lindbergh will use one in his attempt to make the first nonstop flight from New York to Paris. (University of Delaware, Special Collections Department.)

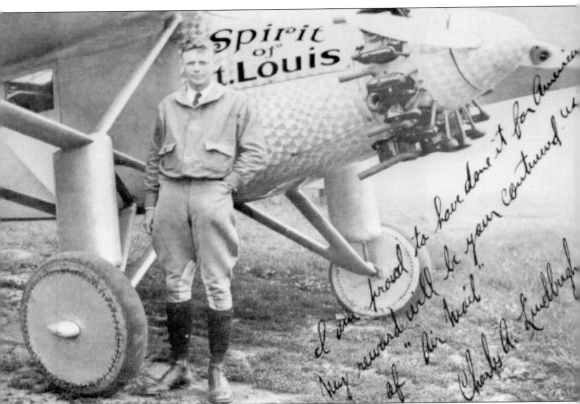

I am proud to have done it for America

My reward will be your continued us

of "air mail"

Charles A. Lindbergh

At 7:52 a.m., May 20, 1927, Charles Lindbergh gunned the engine of the *Spirit of St. Louis* and aimed it down the dirt runway of Roosevelt Field, Long Island. Heavily laden with fuel, the plane bounced down the muddy field, gradually became airborne, and barely cleared telephone wires at the field's edge. A crowd of 500 thought it had witnessed a miracle. After 33.5 hours and 3,500 miles, Lindbergh landed in Paris, the first person to fly the Atlantic alone. (Minnesota Historical Society.)

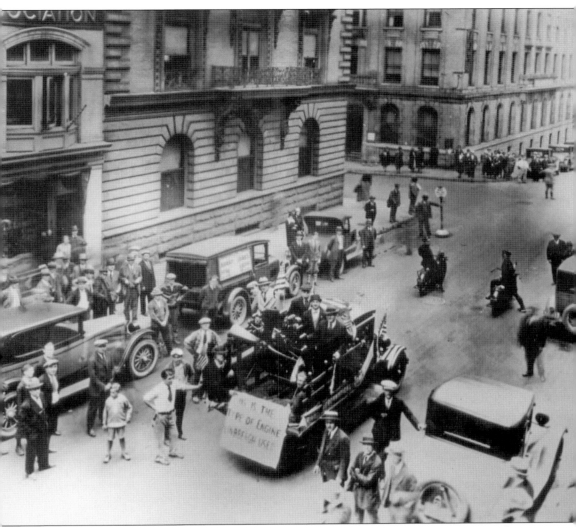

Paterson joined in celebrating Charles Lindbergh's solo transatlantic flight on May 21, 1927. The pickup truck is carrying a Wright Aeronautical J-5 engine similar to the one that was built for the *Spirit of St. Louis*. The truck traveled the streets of Paterson and sits in front of the Hamilton Club on the corner of Ellison and Church Streets. (Paterson Museum.)

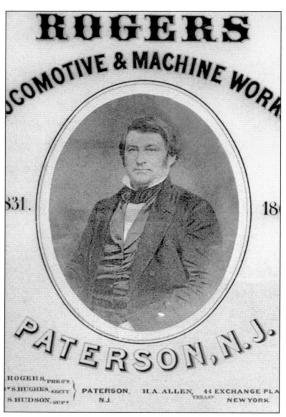

Thomas Rogers (left) was a young machinist who broadened his manufacturing scope by producing the nation's newly developed giant workhorses, steam locomotives. The Rogers Locomotive Works (below) clearly chronicles Paterson's unique role in the industrial cycle. After an early affiliation with the pioneer textile firm of Goodwin, Rogers, and Company, Rogers launched his own enterprise in 1831. He abandoned textile production in favor of the machinery that manufactured it. But Rogers soon became restless, and the infant steam industry caught his attention. After studying a dismantled English engine, he applied his mechanical genius to the 1835 construction of the famous Sandusky, the city's first locomotive, for an Ohio railroad. With the national demand for train engines increasing, the firm became America's locomotive giant. Rogers boasted that he had built five railroad engines in a single year, and by 1850, the plant turned out more than 100 locomotives a year. (Both, Paterson Museum.)

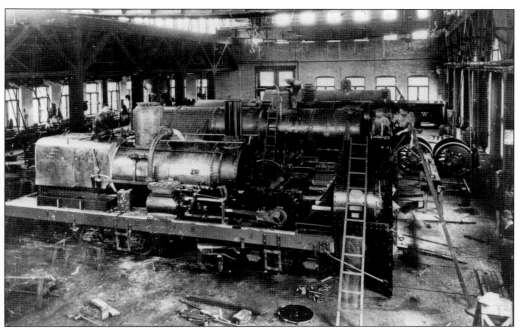

The massive wooden portals of the towering structure of the Rogers Locomotive Erecting Shop, located at the corner of Market and Spruce Streets, clearly indicate the scale of the giant locomotives assembled therein (above). Inside the unadorned brick facade constructed in 1871, technicians, craftsmen, and machinists (below) linked their talents to produce a third of the locomotives that united the nation. Although initially involved in the manufacture of textile machinery, Thomas Rogers revolutionized the locomotive industry by developing counterbalanced wheels and hollow spoke rims. (Both, Paterson Museum.)

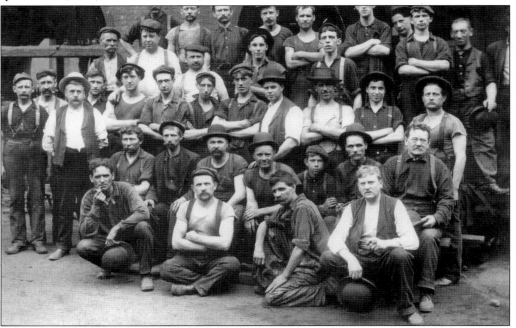

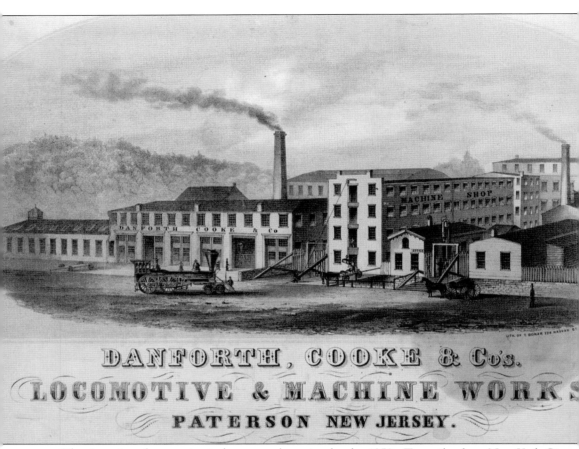

DANFORTH, COOKE & Co's.
LOCOMOTIVE & MACHINE WORKS
PATERSON NEW JERSEY.

The American locomotive industry was booming by the 1850s. Ten miles from New York City, Paterson became the center of the locomotive business. This print from the 1850s portrays the Danforth, Cooke, and Company Locomotive and Machine Works in Paterson. Displayed in the front of the large assembly building is a new locomotive; however, it is not shown riding atop train tracks so the artist obviously took some license with his drawing. Rogers Locomotive Works had tremendous success as a competing company. Following his success, Grant, Danforth, Cooke, and Swinburne all developed steam companies bearing their names. Eighty percent of all American steam locomotives were made in Paterson by the third quarter of the 19th century. Until it merged with seven other manufacturers to form American Locomotive Company (ALCO) in 1901, Cooke Locomotive and Machine Works manufactured locomotives until 1852. Up until 1926, ALCO continued to build new locomotives at the Cooke plant. (Paterson Museum.)

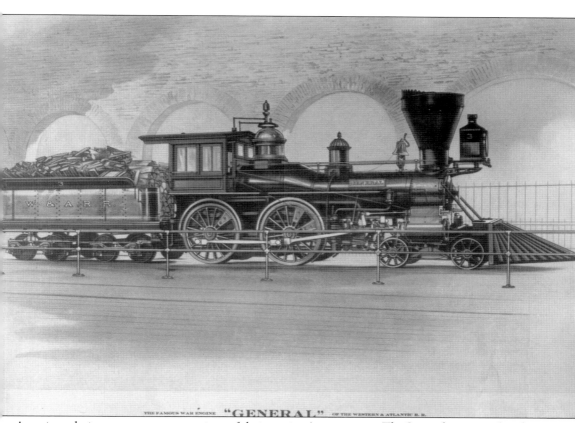

THE FAMOUS WAR ENGINE "GENERAL" OF THE WESTERN & ATLANTIC R. R.

American designers were very conscious of their engines' appearance. *The General* was completed in Paterson in December 1855; and her sister locomotive, *The Texas*, was completed in Paterson in January 1856. The train provided transportation and freight service between Chattanooga and Atlanta on the Western and Atlantic Railroad. *The General* would have had no claim to fame had it not been caught up in a dramatic action in the Civil War. On April 12, 1862, it was hijacked at Big Shanty (now Kennesaw), Georgia, and the "great locomotive chase" ensued before *The Texas* finally caught up with it. The above mentioned "chase" served as the inspiration for many locomotive chases and train robberies portrayed in Western movies. Since 1972, *The General* has spent retirement at the Southern Museum of Civil War and Locomotive History in Kennesaw, Georgia. (Paterson Museum.)

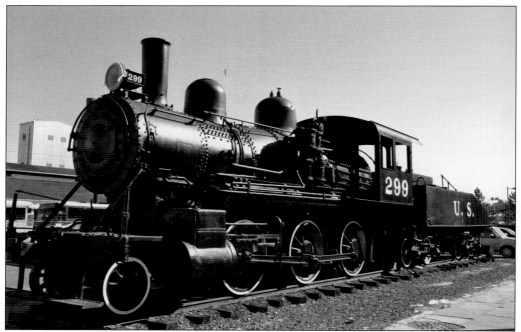

After a little maneuvering, engine No. 299 returned home to America's oldest industrial city. The 62-ton locomotive, built in Paterson in its industrial heyday, was taken out of Panama to be shown among monuments attesting to American ingenuity and technology. No. 299 is one of the surviving locomotives used in the construction of the Panama Canal. It was among 100 built for the job at Paterson's Alco Cooke Locomotive Works in 1906. In all, 144 of the 246 engines used to build the canal came from Paterson. (Both, author's collection.)

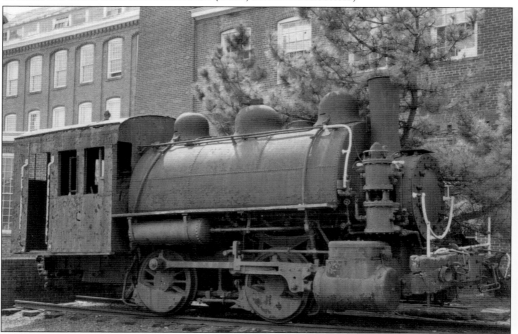

In 1976, Mayor Lawrence F. Kramer (below) began looking for a locomotive built during Paterson's bustling locomotive years, 1837 to 1912. Wednesday, June 6, 1979, marked a historic day for the city. Wearing an engineer's cap, Mayor Kramer (right) leads ceremonies marking the return of Engine No. 299 to Paterson, where it was built. The locomotive was used in building the Panama Canal. Kramer was dubbed a latter-day Jesse James for his role in getting the 30-foot-long engine and its 27-foot-long, 20-ton coal car out of the Panama Canal Zone after the Panama Canal Treaty of 1977 was signed. Kramer and supporters paid $299 to accompany the engine's return, since No. 299 was the centerpiece he was looking for to place in the newly designated Great Falls of the Passaic/S.U.M. Historic District. "They have the canal, we have No. 299," Kramer was quoted as saying. (Both, author's collection.)

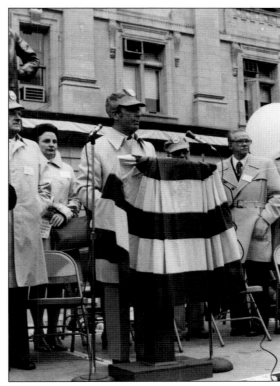

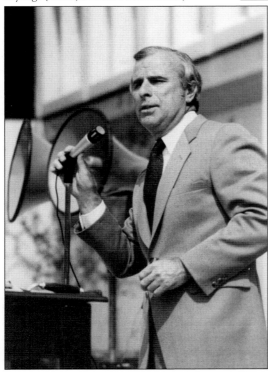

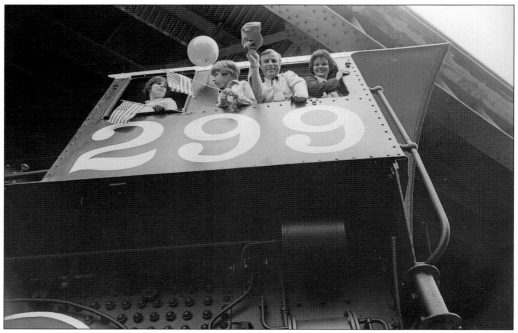

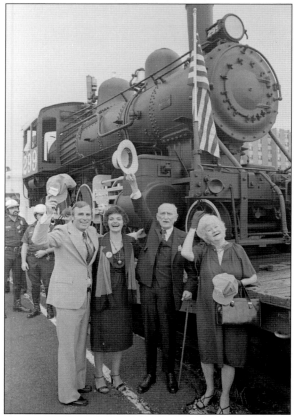

Joining in the celebration of the arrival of Engine No. 299 are former mayor Lawrence F. Kramer, Mary Ellen Kramer, and their children Kip and Kelly Kramer. On June 6, 1979, the Paterson, New Jersey, post office had a special one-day cancellation for the return of Engine No. 299 from Panama. The engine continued to run until 1953, when it was retired and placed in front of the Balboa Heights Railroad Station. It now stands in front of the Paterson Museum, which is housed in the Rogers Locomotive Erecting Shop. (Above and left, Paterson Museum, photographs by Michael Spozarsky.)

John P. Holland (right), inventor, designer, and builder of the U.S. Navy's first practical submarine, immigrated to Paterson from Ireland in 1873. While teaching at St. John's Parochial School, he drew up plans for and constructed his first submarine (below) in a machine shop on Van Houten Street. It saw the light of day in 1877. (Both, Paterson Museum.)

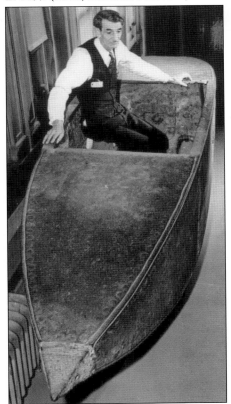

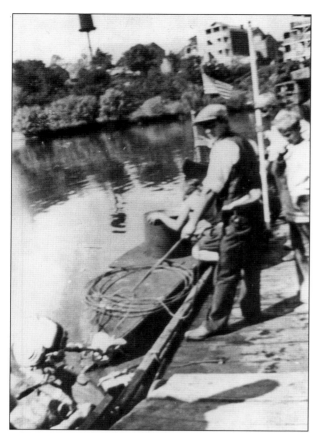

On May 22, 1878, the submarine was brought down to the Passaic River and launched before a small audience, but someone forgot to insert two screw plugs and the submarine promptly sank to the bottom of the river near the Spruce Street Bridge. (Both, Paterson Museum.)

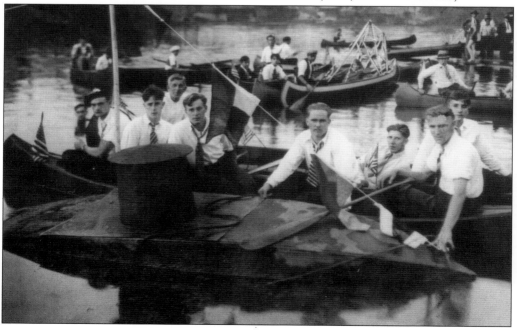

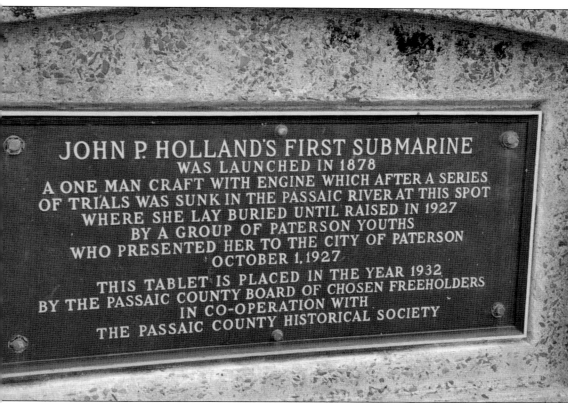

JOHN P. HOLLAND'S FIRST SUBMARINE
WAS LAUNCHED IN 1878
A ONE MAN CRAFT WITH ENGINE WHICH AFTER A SERIES
OF TRIALS WAS SUNK IN THE PASSAIC RIVER AT THIS SPOT
WHERE SHE LAY BURIED UNTIL RAISED IN 1927
BY A GROUP OF PATERSON YOUTHS
WHO PRESENTED HER TO THE CITY OF PATERSON
OCTOBER 1, 1927

THIS TABLET IS PLACED IN THE YEAR 1932
BY THE PASSAIC COUNTY BOARD OF CHOSEN FREEHOLDERS
IN CO-OPERATION WITH
THE PASSAIC COUNTY HISTORICAL SOCIETY

It was raised 50 years later by a group of resourceful young boys using a magnet to locate the scuttled hull in the river's mud. A plaque on the bridge at the end of Front Street describes the exploits of these youths. They presented *Holland I* to the city of Paterson in 1927, and it is currently on display at the Paterson Museum. When the submarine was recovered, Dominic Conti, the owner of a sandwich shop and grocery store on Mill Street who served tubular-shaped sandwiches remarked, "It looks like the sandwich I sell at my store." He then began calling them submarine sandwiches. (Author's collection.)

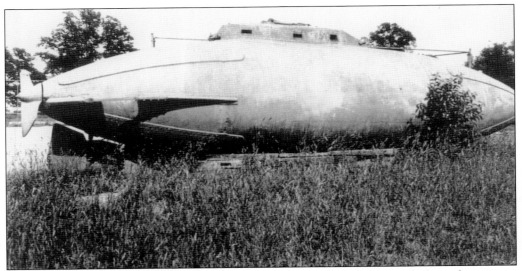

In 1916, the *Fenian Ram* was taken to Madison Square Garden in New York City where it was exhibited in order to raise funds for victims of the Irish Uprising. Afterward it was moved to the grounds of the New York State Marine School. This shows the submarine at the school sometime between 1916 and 1923. (Paterson Museum.)

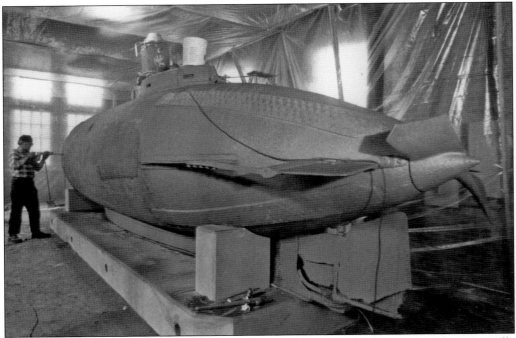

The *Fenian Ram*'s weapon was a pneumatic gun, shooting a projectile out of the bow. Initially there were serious problems with the gun, as the projectile would take a sharp turn upward and leap out of the water. John Holland solved this by drilling a hole near the muzzle of the barrel that would allow the charge of compressed air behind the projectile to vent through the hole preventing the column of air from kicking the bottom of the projectile down and shooting it up. (Paterson Museum.)

As a monument to John Holland, Edward Browne purchased the *Fenian Ram* in 1927 and placed it in Westside Park, in Paterson's Totowa section of the city. It remained in the park until 1980 when Kennedy High School was built there, and it was then moved, along with Holland's papers, indoors to the Paterson Museum. While in the park, visitors (like the author and the author's mother) took pictures while standing in front of the fenced-in submarine. It serves as a reminder of the ingenuity of the father of the modern submarine. (Right, Paterson Museum; below, author's collection.)

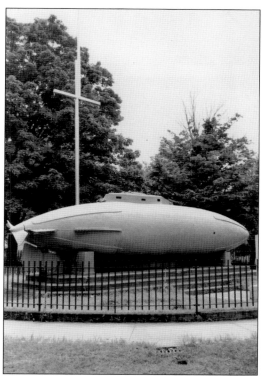

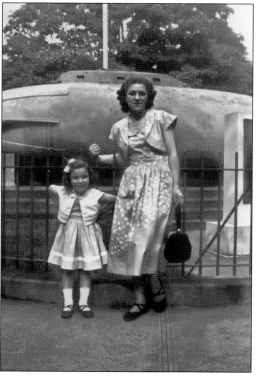

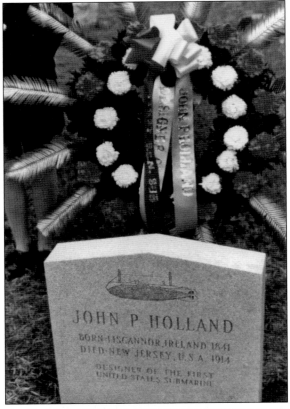

The U.S. government bought the *Holland VI* on April 12, 1900, and it became the first commissioned submarine in the American navy on October 12, 1900. The true significance of Holland's invention would become apparent to the world beginning with the start of the First World War, the first conflict in which submarines played a major role. But John Holland died only a few months before the first ever sinking of a warship by a torpedo launched by a submarine, at the opening of the war. Holland died in Newark, New Jersey, in 1914, and he is buried in Holy Sepulcher Cemetery in Totowa, New Jersey. The headstone at left was Holland's original headstone. It was replaced with the headstone seen below and "dedicated Oct. 10, 1976 by the Submarine Veterans, Past Present and Future." (Left, Paterson Museum; below, author's collection.)

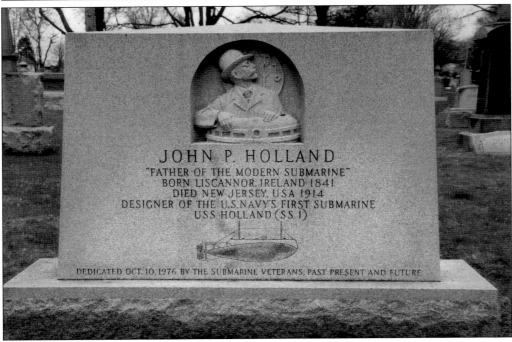

Eight

SOUVENIR POSTCARDS

Greetings from Paterson, New Jersey: This is a look at souvenir postcards from the early 1900s. Even then, the Falls were a tourist attraction. New Yorkers had discovered the northeast corridor of New Jersey in the 1880s as ideal for day excursions; after all, the Great Falls of the Passaic were a lot closer than Niagara Falls. People came from all over to visit the thundering cascade.

Sending postcards became a fad toward the end of the 19th century, when traveling Americans wrote their sentiments on these thin 3.5-by-5.25-inch pieces of card stock with local attractions and views printed on the front sides. Cameras were not commonplace yet, so visitors bought the small cards, scribbled some sort of message, stamped the cards, and mailed them out. These little postcards solved a lot of communication problems, especially for people who did not like to write letters. The telephone was not affordable or commonplace either, so sending postcards was an inexpensive way to let family and friends know when they had arrived at a destination. Buying and sending postcards remains popular today.

Everywhere tourists went in New Jersey, postcards were sure to be there, and Paterson and the Great Falls were no different. Interestingly enough, the postcards depicted here were printed in Germany, where printing techniques had been perfected.

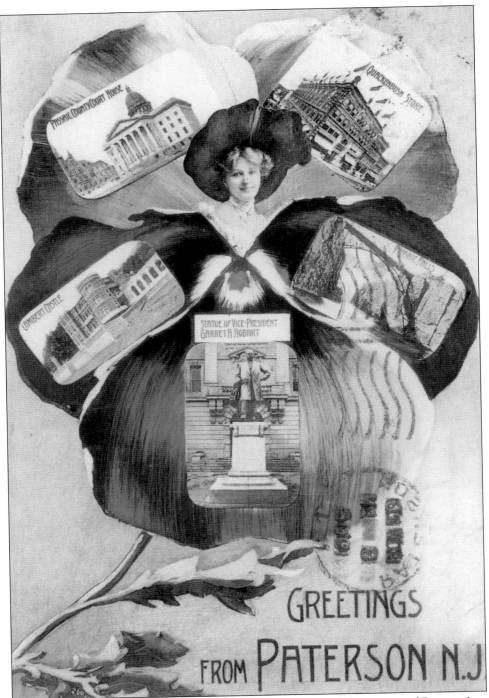

This postcard has a postmark date of 1918. The scenes depicted show some of Paterson's more important attractions. Day-trippers turned their desire for rest and relaxation into overnight journeys. New Englanders and Canadians came to New Jersey on their way to sunnier climates, and southerners wanting to escape the crushing heat made their way north. (Paterson Museum.)

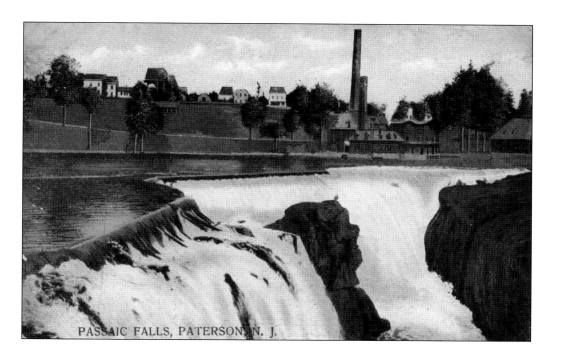

PASSAIC FALLS, PATERSON, N. J.

As the Falls were treacherous no matter what the season, in the early days of Paterson, many people lost their lives picking their way along the edges just to see the dramatic drop. For some it was a cheaper vista than traveling all the way to Niagara Falls. (Both, author's collection.)

2601 Passaic Falls in Winter, PATERSON, N. J.

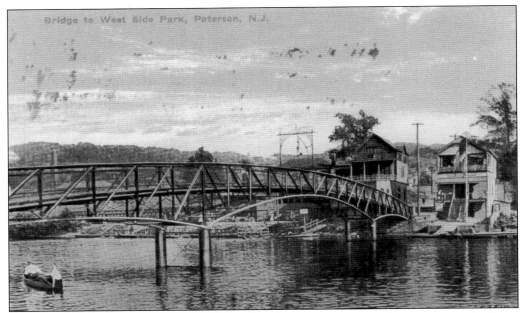

Boats or canoes were readily available for rent to take out on the Passaic River in the early 1900s. The Passaic Valley Canoe Club had a membership of 125 and a clubhouse that could accommodate 82 crafts. In November 1907, two members of the club overturned while attempting to navigate the river. The current had been very strong due to recent rains, and they had been warned by other members not to go. While returning to the boathouse, one of the men attempted to get a snapshot, and the canoe overturned, went over the Falls, and broke into pieces. Both men had difficulty getting out from under the overturned canoe, but they struck out for shore, yelled for help, and attracted two men on the bank. It took six tries before the canoeists were brought safely to shore. (Both, Paterson Museum.)

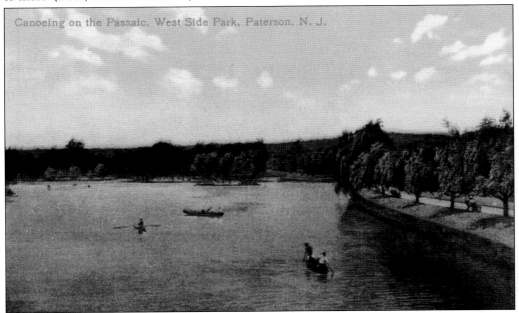

Canoeing on the Passaic, West Side Park, Paterson. N. J.

The Great Falls have long been seen as unmatched for their picturesque surroundings even as they are undoubtedly unique in their configuration. Among the chief attractions are the beautiful rainbows that form in the spray and frequently hang over the cataract. (Paterson Museum.)

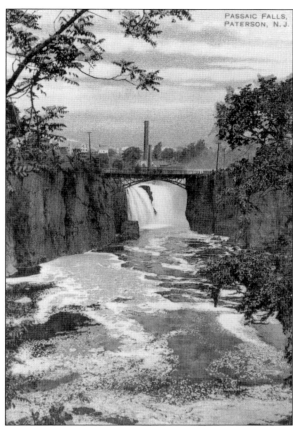

Since writing on the address side of any postcard was not permitted by law until March 1, 1907, many postcards mailed up to 1907 had messages written across their fronts. Germany, where most postcards were printed, had been the world leader in lithographic processes up until World War I. After the war, Germany could no longer supply postcards, but England and the United States could, even if they were of poorer quality. The German publishing industry never rebounded. During the war years, the telephone replaced the postcard as a fast and reliable means of keeping in touch. (Author's collection.)

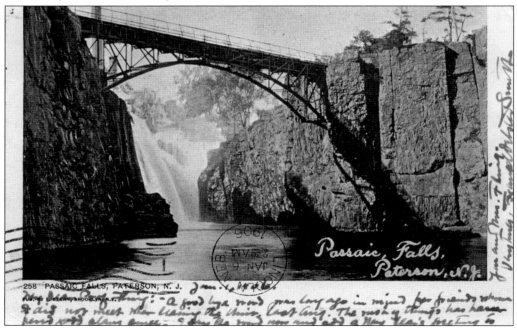

105

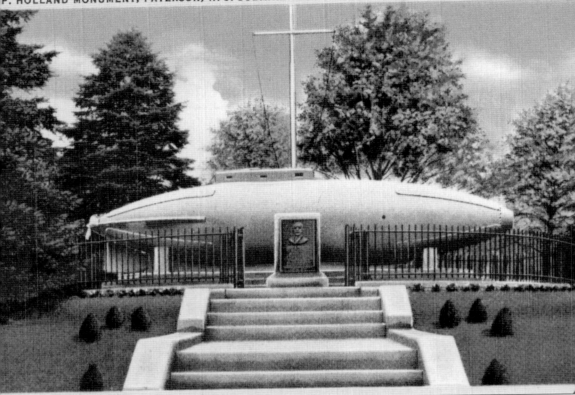

Postcards were popular because of the wide range of subjects, with just about every topic imaginable at some time portrayed on a postcard. History itself can be traced on postcards from historical buildings, famous people, art, holidays, and more. It was not long before Paterson, like other cities, was creating postcards depicting famous and scenic spots in and around the city. (Paterson Museum)

Nine

GREAT FALLS FESTIVAL

Mary Ellen Kramer put together Great Falls Park in 1971 with some assistance from Paterson's city officials and a host of volunteer effort. The first Great Falls Festival, planned in a matter of weeks and held on September 4, 1971, followed. It was Kramer's way of celebrating the opening of the park, bringing Paterson's people together to have a good time, honoring the city's national historic district, and celebrating the labor movement. All proceeds went to the Great Falls Development Corporation for restoration of the Falls. The festival started out small, attracting few participants.

In 1981, Mayor Frank X. Graves Jr. stopped the festivals for economic reasons. But in 1991, nineteen years later, then mayor William J. Pascrell Jr., now a congressman from the Eighth Congressional District, resurrected a scaled-down version of previous years' celebrations. The Great Falls Environmental Festival was held over the Fourth of July holiday rather than Labor Day weekend.

For several years the event combined the historic attraction with the commemoration of Independence Day. Since 1994 was the 100th anniversary of the Labor Day movement, Paterson's unique event occurred Labor Day weekend (September 3, 1994) and has been held then ever since.

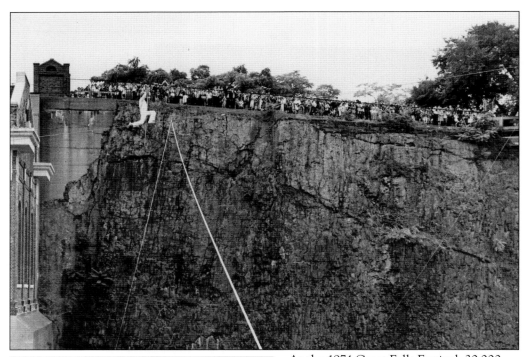

At the 1974 Great Falls Festival, 30,000 spectators held their breath as French aerialist Philippe Petit crossed a cable strung 100 feet above the swirling waters. The walk lasted eight and a half precarious minutes, each step a dizzying one on the 280-foot wire. In the background, the Great Falls itself and a sign reading "Paterson" suspended on the bridge were flashed around the world. (Paterson Museum, photograph by Michael Spozarsky.)

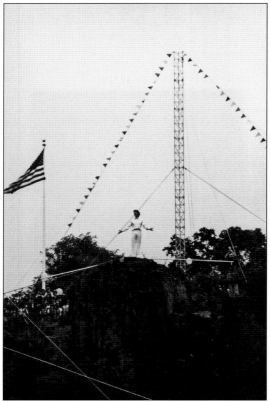

More than 45,000 people attended the four-day Labor Day celebration, culminating in a high-wire act by 25-year-old Philippe Petit, who had startled the world with his walk between Manhattan's World Trade Center towers the month before. Petit told Paterson mayor Lawrence F. Kramer that he was an artist and not a circus entertainer. The mayor discovered that for himself as he fed Petit gallons of orange juice during the long weekend and stood by while the setup was rigged and re-rigged following a night of torrential rain. (Paterson Museum, photograph by Michael Spozarsky.)

The festival has grown considerably since 1971, and crowds now flock to the Great Falls Festival, the official event of the city of Paterson. Entertainment, fireworks, parades, arts and crafts, and food stands are just some of the attractions with which organizers lure people to the heart of this country's first planned industrial city, showing America that its urban centers are vital to the cultural, industrial, and business lives of the nation. (Both, photographs by Richard Gigli.)

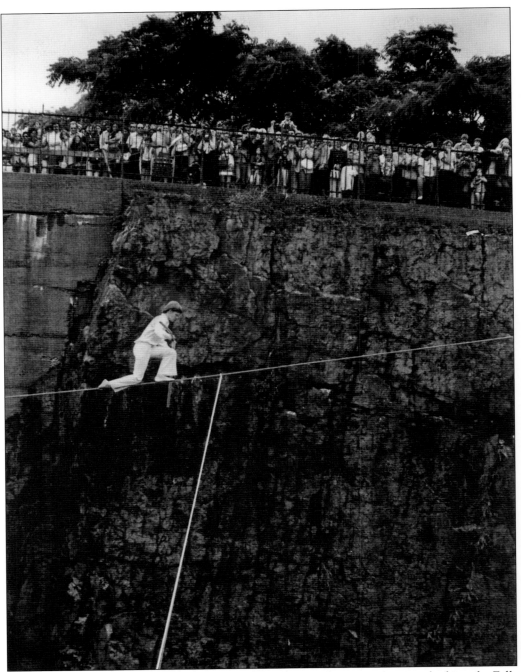

Over the years, crowds of onlookers have pressed up against the iron railing overlooking the Falls and watched various daredevil acts, such as Philippe Petit, who at times found it difficult to keep a point of reference and maintain balance with the Falls providing a dramatic backdrop and the water flowing underneath. (Paterson Museum, photograph by Michael Spozarsky.)

Ten

THE HISTORIC DISTRICT

In the early 1970s, a small and informal group was being formed under the leadership of Mary Ellen Kramer, whose husband Lawrence "Pat" Kramer served as mayor for four years beginning in 1967. Back then, the state wanted to tear down dozens of historic old mill buildings in order to expand Route 20 right through the downtown area. Mary Ellen Kramer was one of the key people who led efforts that blocked that project. For years, there had been plans to expand Route 20 and turn it into a six-lane highway, plowing through the city of Paterson and blocking the view of the Great Falls. Once the highway was stopped, Kramer and others established what later became the Great Falls Preservation and Development Corporation, which started pressing for the preservation of downtown Paterson in 1965. It enjoyed a few early but short-lived successes.

Attention was first centered on the area when a group of citizens applied to have the Great Falls recognized as a national natural landmark, a designation approved in 1967 by the U.S. Department of the Interior. Three years later, in 1970, the group successfully landed the waterfall vicinity and the surrounding industrial area on the National Register of Historic Places. This led to the confirmation of the district as a national historic landmark by Pres. Gerald R. Ford on June 6, 1976, the bicentennial year. On that day, the Great Falls joined a list of 21 other landmarks that were the settings for important facets and important actions in the drama of the nation's industrial development—including such sites as Mount Vernon and Monticello.

For more than a decade at the forefront of a movement to preserve the city's history and use it as a foundation of renewal, Mary Ellen Kramer was the engine, gears, and wheels of an effort to keep Paterson an exciting place to live and visit. It was her vision, courage, and determination that brought the area to life again. She says in "Paterson People in the March of Time" (a pamphlet published in 1972): "It is my feeling that any view of Paterson's future must be, by the nature of cities, one that carries with it a sense of her past. It must include a look backward and a look forward at the economic, political, social and cultural facets which have been part of the city's fabric for almost 200 years. It is important that we keep some of the old buildings, even though we design them for new uses so that we do not lose the sense of that on-going life out of the past, into the present and for the future. The area of the Falls and its surrounding buildings as well as other landmarks throughout the city give support to our understanding of the flow of life and events in the city and the directions in which we can go." (Kramer family.)

112

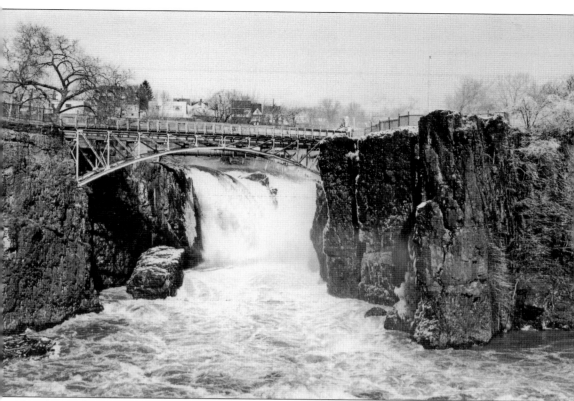

In 1970, culminating a quiet two-year campaign for recognition, an 89-acre site covering the Falls, some 40 aging mill buildings, and the three-level raceway had been designated a national historic district by the U.S. Department of the Interior's National Park Service. (Paterson Museum, photograph by Michael Spozarsky.)

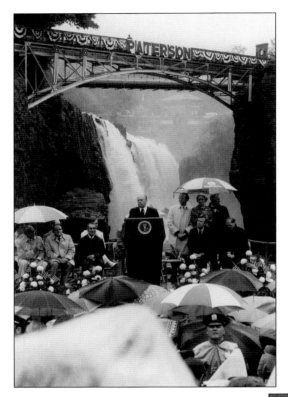

On a rainy afternoon in Paterson, Pres. Gerald R. Ford, just weeks before America's bicentennial, officially designated the 119-acre Great Falls/S.U.M. historic district a national historic landmark on June 6, 1976. President Ford fully understood the history of America's industrial economy and recognized Paterson as its birthplace. Sheets of rain swelled the Passaic River, demonstrating the Falls' incredible power. With water thundering down from a precipice 77 feet above, President Ford described the Falls as "a symbol of industrial might which helps make America the most powerful nation in the world." (Paterson Museum, photograph by Michael Spozasky.)

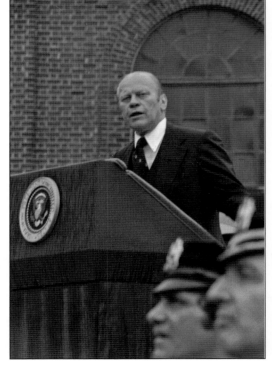

In his remarks at the dedication ceremonies at the Great Falls, President Ford stated that "the ancient energy of the Great Falls themselves and the new energy of the citizens of Paterson can propel this area into a new age, even greater than that foreseen more than 200 years ago by Alexander Hamilton. Those same natural resources, the American earth, and the American people will ensure that his vision of a free and prosperous nation will remain a reality for a long, long time." (Author's collection.)

On October 21, 2004, then governor James E. McGreevey, along with state and federal officials and more than 100 local residents, gathered at the Great Falls to hear the governor announce the designation of the Great Falls Historic District as Great Falls State Park. (Author's collection.)

Prior to its authorization as a national historical park, Speaker of the House Nancy Pelosi visits Paterson and the Great Falls with Rep. William J. Pascrell Jr. They stand at the railing with the Great Falls as a backdrop as Pascrell briefs Pelosi on the city's history and how Alexander Hamilton harnessed the power of the Passaic River to spur manufacturing in the Silk City. Pelosi was presented with a framed portrait of the Falls during her half-hour stay at the park. (North Jersey Media, photograph by Michael Karas.)

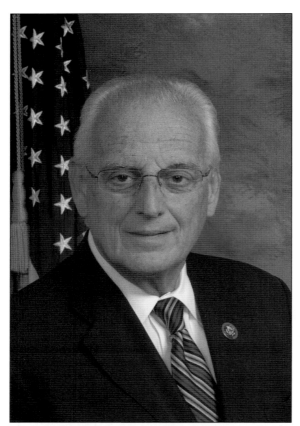

In addition to many preservation and conservation advocates who have worked for years to see its creation, William J. Pascrell Jr. (left), a U.S. Representative, former mayor of the city of Paterson, and a Paterson native, was the driving force behind the campaign to turn the Great Falls Historic District into a national historical park (below). "Paterson will finally be recognized for the seminal role it has played in shaping American history. This marks an historic moment for the city of Paterson and the state of New Jersey. This place is a hidden jewel—the history here is so rich and this city really deserves this recognition. There is no place like it in the United States," Pascrell is quoted as saying at a press conference in 2009. (Left, Congressman William Pascrell Jr.; below, author's collection.)

On April 15, 2009, city residents and activists, many of whom fought for decades for the historical designation, crowded under a white tent set up opposite the 77-foot Falls. Congressman William J. Pascrell Jr. (above) and U.S. Sen. Frank Lautenberg, both native Patersonians, and U.S. Sen. Robert Menendez gathered to praise the teamwork of the many players involved in gaining national park status for the Falls (right), once a seemingly impossible goal. They were excited to move forward with plans to open this park. (Both, author's collection.)

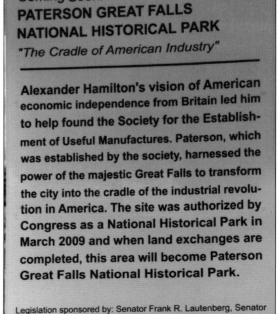

Coming Soon:
PATERSON GREAT FALLS NATIONAL HISTORICAL PARK
"The Cradle of American Industry"

Alexander Hamilton's vision of American economic independence from Britain led him to help found the Society for the Establishment of Useful Manufactures. Paterson, which was established by the society, harnessed the power of the majestic Great Falls to transform the city into the cradle of the industrial revolution in America. The site was authorized by Congress as a National Historical Park in March 2009 and when land exchanges are completed, this area will become Paterson Great Falls National Historical Park.

Legislation sponsored by: Senator Frank R. Lautenberg, Senator Robert Menendez, and Congressman Bill Pascrell, Jr.

"The Great Falls in Paterson is a landmark that deserves recognition as a national historic park. Giving the Great Falls this designation would go a long way toward recognizing the beauty of the site and helping preserve it for future generations," remarked Sen. Frank Lautenberg, also a Paterson native, on April 15, 2009. (Author's collection.)

"Our national park system isn't just about giant spaces out West," Sen. Robert Menendez said. "It's also about preserving places of national significance here in New Jersey, which sustains our history and provides recreation for everyone." The federal designation reinforces the notion that the Great Falls are just as significant to the history of the American people as larger and better-known parks such as Yellowstone. (Author's collection.)

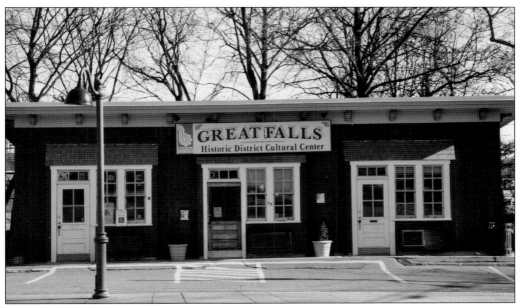

The Great Falls Historic District Cultural Center (above) is conveniently located directly across the street from the Falls. At the intersection of Spruce Street and the McBride Avenue extension, it is housed in what had been an abandoned gas station, which was taken over by the city. The center is a facility of the Paterson Museum and no longer under the Department of Community Development and provides a variety of services to educators, students, and researchers—including walking tours of the historic district's industrial architecture and history and of the area surrounding the Falls. Interpretive exhibitions on Paterson history, including photography, poetry, and artwork (below), are among the center's offerings. (Both, author's collection.)

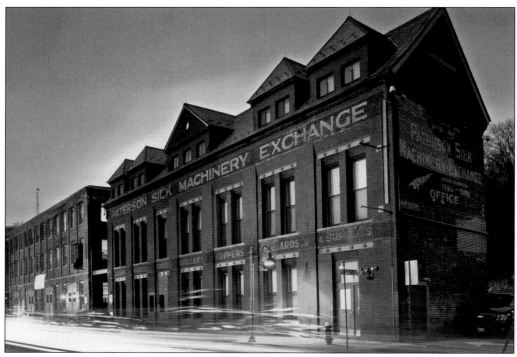

Paterson's finest structure architecturally is the old Rogers administration building (above), which has "Paterson Silk Machinery Exchange" painted across its facade as a reminder of a later tenant. With windows set deep into a strong, solid facade, it is made of brick a richer and deeper red than those in the erecting shop (below). Architecture clearly demonstrates a difference in status between the headquarters and the working structures. Both buildings are in the heart of the historic district. (Both, photographs by Ron Saari.)

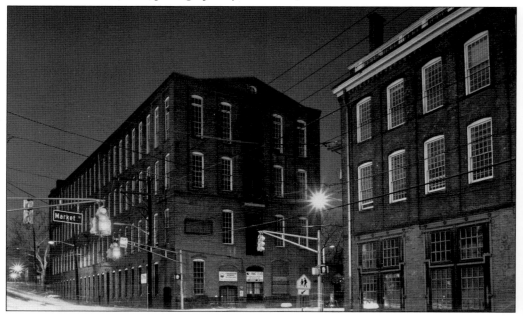

The Paterson Museum was established in 1925 by the library's board of trustees to house the various collections that had been stored in the library. After beginning operations in the Assembly Room of the Danforth Public Library with a display of natural history items donated by local residents, the museum opened in January 1927 in the carriage house of former Paterson mayor and philanthropist Nathan Barnert, located at 278 Summer Street, next to the library. Over the years, its collections grew in size and scope and additional space was needed. In 1982, Mayor Frank X. Graves Jr. relocated the museum to the restored Rogers Locomotive Erecting Shop at the corner of Market and Spruce Streets in the heart of the Great Falls Historic District. It houses one of the finest mineral collections in the state of New Jersey, including a fluorescent mineral display housed in a simulated mine. In addition, its exhibits reflect the history of Paterson by showing its evolution as a center of textiles and machinery, locomotive manufacturing, Colt firearms, and Holland submarines. (Author's collection.)

An old pulley is still visible on the south side of the Paterson Museum. The doorways that are now closed off undoubtedly were where raw materials and finished goods were moved in and out of the work spaces. A sign on the building denotes its place in the historic district. (Author's collection.)

In May 1949, Paul Agrusti and the Betts brothers, with experience in the hot Texas weiner business, opened the Falls View Grill (above) where Market and Spruce Streets intersect. Centrally located, convenient to working people and major highways at the time, it was successful for many years. Agrusti left in 1978 to open another business. The brothers continued the grill until 1984, when they sold to new buyers, who were unsuccessful and resold in 1988. The building, in the midst of Paterson's historic manufacturing district, now houses a Burger King (below). One of the stipulations of sale was that the structure maintain the integrity of the restored buildings around it. (Above, Paterson Museum; below, photograph by Christine Fontanazza.)

Overlook Park was created in 1964 during the administration of former mayor Frank X. Graves Jr. in a campaign spearheaded by Harry B. Haines, publisher of the Paterson News. The park was first called Haines Park in his honor. (Author's collection.)

The Passaic Valley Water Commission, begun in 1849 as the Passaic Water Company, was incorporated and secured franchises for the distribution of water in New Jersey to the town of Paterson and its environs. It obtained water from the Passaic River. The pump house was built between 1874 and 1887 to move water up to the company's reservoirs. System components included a dam, headrace, pump house with wheel, tailrace, and pipes to reservoirs; it was abandoned when steam power became more practical. Up until then, the water was untreated and pumped directly into the pipelines. The poor quality of water in Paterson at the beginning of the last century prompted the water company to build a filtration plant at the Little Falls site, the first of its type in the country. (Photograph by Richard Gigli.)

The larger house in the photograph once belonged to cotton manufacturer Daniel Thompson and the smaller one to English silk weaver John Ryle, considered the "Father of the Silk Industry" in Paterson. Ryle came to Paterson in 1839 to run a silk mill located in the old Colt Gun Mill and owned by George W. Murray. In 1845, Ryle formed a partnership with Murray and bought him out the following year. When Ryle built his house in 1849, it was located on the corner of Ward and Mill Streets, across from a silk mill that he built in the 1850s. Both houses were later moved to their present location at Mill and Ellison Streets at the bottom of the McBride Avenue extension. (Photograph by Christine Fontanazza.)

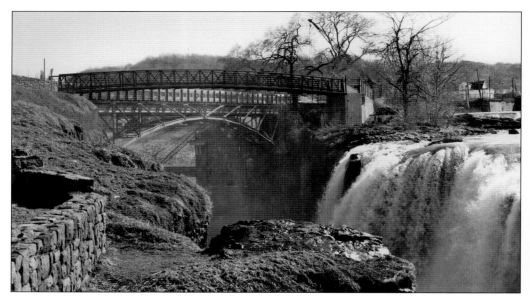

This park overlooking the Great Falls was dedicated in September 1972 during the Great Falls Festival. Gov. William T. Cahill had the honor of also opening a new 70-foot-high pedestrian bridge over the chasm (above). This view is of the Great Falls and the cleft in the rock from the overlook off Maple Street (below). This spot offers a view of the cascade from the Passaic Valley Water Commission Pumping Station. Paths around the park, previously off limits to visitors, were opened in 1972. Mary Ellen Kramer and a group of activists reclaimed parkland from a barren, fenced-off property behind the Passaic Water Company pumping station. The park was renamed in her honor after her death in 1993. Today it is an urban oasis where curved pathways cross over the park. (Both, author's collection.)

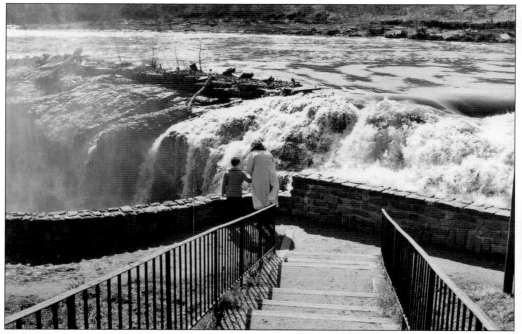

BIBLIOGRAPHY

Capo, Fran. *It Happened in New Jersey*. Guilford, CT: Globe Pequot Press, 2004.

Chernow, Ron. *Alexander Hamilton*. New York: Penguin Books, 2004.

Cunningham, John T. *This is New Jersey*. New Jersey: Rutgers University Press, 2001.

Drashevska, Lubov. *The Geology of Paterson, New Jersey: With a Field Guide*. Paterson Museum, 1976.

Genovese, Peter. *New Jersey Curiosities*. Guilford, CT: Globe Pequot Press, 2007.

Johnson, Paul E. *Sam Patch, the Famous Jumper*. New York: Hill and Wang, 2003.

Kennedy, J. *The Falls of Passaic: A Visit from New York to Paterson*. New York: B. Waugh and T. Mason, 1833.

Kline, Mary-Jo, ed. *Alexander Hamilton: A Biography In His Own Words*. New York: Harper and Row.

Longwell, Charles Pitman. *A Little Story of Old Paterson as Told by an Old Man*. 1901.

"The Minutes of the Society for Establishing Useful Manufactures." Available at the Paterson Library, 250 Broadway, Paterson, New Jersey.

Norwood, Christopher. *About Paterson: The Making and Unmaking of an American City*. New York: Saturday Review Press, E. P. Dutton and Company, 1974.

Stanfield, Charles A. Jr. *A Geography of New Jersey: The City in the Garden*. New Jersey: Rutgers University Press, 1998.

Trumbull, Levi. *A History of Industrial Paterson*. New Jersey: Paterson, Carleton M. Herrick, Book and Job Printer, 1882.

Widmer, Kemble. *The Geology and Geography of New Jersey*. Van Nostrand Company, Inc. New Jersey Tercentenary Commission.

Williams, William Carlos. *Paterson*. New York: New Directions Paperbook, 1963

www.arcadiapublishing.com

Discover books about the town where you grew up, the cities where your friends and families live, the town where your parents met, or even that retirement spot you've been dreaming about. Our Web site provides history lovers with exclusive deals, advanced notification about new titles, e-mail alerts of author events, and much more.

Find Your Place in History.